Official Know-It-All Guide™

MAGIC *for* BEGINNERS

Walter B. Gibson
Mike Shelley, Contributing Editor

Official Know-It-All Guide™

MAGIC *for* BEGINNERS

Walter B. Gibson
Mike Shelley, Contributing Editor

Fell's

Frederick Fell Publishers, Inc.
2131 Hollywood Blvd., Suite 305, Hollywood, FL 33020
Phone: (954) 925-5242 Fax: (954) 925-5244
Web Site: www.Fellpub.com

Frederick Fell Publishers, Inc.
2131 Hollywood Boulevard, Suite 305
Hollywood, Florida 33020
954-925-5242
e-mail: fellpub@aol.com
Visit our Web site at www.fellpub.com

Published by Frederick Fell Publishers, Inc., 2131 Hollywood, Blvd., Suite 305, Hollywood, Florida 33020.

This publication is designed to provide accurate and authoritative information in regard to the subject matter covered. It is sold with the understanding that the Publisher is not engaged in rendering legal, accounting, or other professional service. If legal advice or other assistance is required, the services of a competent professional person should be sought. *From A Declaration of Principles jointly adopted by a Committee of the American Bar Association and a Committee of Publishers.*

Library of Congress Cataloging-in Publication Data

Gibson, Walter Brown, 1897
 Fell's official know-it-all guide to magic for beginners / by Walter B. Gibson
 p. cm.
 Rev. ed. of: The complete beginner's guide to magic. c1996/2002
 ISBN 0-88391-079-9
 1. Magic tricks. I. Title: Magic for beginners. II. Gibson, Walter Brown, 1897-
 Complete beginner's guide to magic. III. Title.
 GV1547 .G5119 1999,2002
 793.8--dc21

 99-054215

10 9 8 7 6 5 4 3 2

Table of Contents

PART I

Instant Magician—Featuring Over-Easy Card Tricks
All you need are two decks of cards, a glass and a handkerchief.

The magician discovers the secret number of cards selected by the audience member.

The Queen in the middle of a trio of cards suddenly disappears!

The pre-selected card is picked out of a deck magically.

A fascinating trick of discovery.

The magician discovers the audience's selected card in a heap of other cards.

One person remembers a card and another person names a number. The magician mixes the deck and miraculously puts the first person's card at the spot named by the second.

PART II

King of the Hill—Tricks for the Story Teller
A deck of cards and a sense of drama are what you'll need for these tricks.

PART III

You're on Deck—Advanced Card Tricks
Materials needed: A deck of cards.

PART IV

Tricks With Coins—Featuring Popular Coin Tricks

A few simple materials are needed for these tricks: handkerchief, matchboxes, matches, hat, plate, Chinese coin, ring or metal washer, some string and, of course, coins—a fifty-cent piece or a quarter and pennies.

PART V

Look into My Eyes—Tricks of Hypnotism
*A knotted handkerchief and your own personality are all
you need for these amazing and unsettling tricks.*

PART VI

Round the Table Tricks—Perform Magic Around the Table
*These tricks can be performed at the dinner table or any impromptu
gathering. Matches, matchboxes, rubber bands, a safety pin, handker-
chiefs or cloth napkins, and table items are needed for this series.*

PART VII

All Tied Up—Tricks With String
All that's needed here to produce startling effects is a quantity of string and four rings or metal washers.

PART VIII

Presenting Knots—Knot Tricks with Added Effects
These tricks require some emphasis on presentation, as some are performed "under cover" or require special appliances.

PART IX

Keep an Open Mind—Mental Mysteries

The materials needed for these mysteries are paper and pencils, a watch or clock, two pocket-sized dictionaries, a few skeins of colored yarn, some cold cream, a deck of cards and a confederate friend.

PART X

A Bag of Tricks
Here is a mixed bag of tricks by magician Mike Shelley!

Foreword

I have had a fascination with magic since I was seven years old. I can remember my father taking me to see a magic show at Lollypop Farm out on Long Island. A magician took a strip of material and cut it into two pieces and selected me as one of his assistants. As I waved the magic wand, it fell apart. I waved the magic fan, and it, too, fell apart. Finally, the strip of material was restored. I had to learn how some of this magic was done!

The only way that existed for me to learn was from books. The first book I ever purchased was by Walter B. Gibson. It was called *Magic Explained* and cost me 35 cents. I still have this small, red-covered, yellowed copy of this book sitting in my magic library.

It was only the first of many Walter B. Gibson books that I would purchase. No magic author did as much for the art of magic as Walter B. Gibson did. He was a prolific writer of books and magazine articles about all aspects of magic. He covered the historical aspect by writing a book about Houdini. He was the ghost-writer for Houdini as well, not to mention Howard Thurston, Harry Blackstone and Joseph Dunniger. He wrote hundreds of books for all interested in the art of magic. There were books for experts and beginners alike.

All of the tricks in this book have been carefully tested. This entire book has been given a facelift. Improvements, performance tips, variations, and magic tips all have been added to make this a book that will teach you how to become a magician. I have written a whole new chapter filled with lots of self-working tricks that you will be able to perform with little or no practice. When you are through learning the tricks from this book, you will be able to amaze your friends and your family.

—**Mike Shelley**

Introduction

The best way to learn magic is by doing it. This may surprise people who think that magicians perform their wizardry solely through long study and continued practice, but the main purpose of magic is to baffle the audience, rather than merely to display skill and dexterity. Often, quick moves will excite suspicion, whereas a trick done casually, with a surprise result, will leave an audience bewildered.

In short, some of the simplest tricks are among the best, and this is particularly true from the beginner's standpoint. The simple tricks allow the beginner to concentrate entirely on presentation instead of worrying about a difficult move or the finer points of deception that keen observers are apt to detect unless it is done perfectly. The closer the audience watches for something complex, the more easily they can be deceived by something simple.

All that is helpful to the beginner and all the more reason for trying out some of the simpler tricks soon after learning them. Naturally, practice is helpful, but audience reaction is equally important, so the rule to "learn magic is by doing it" still holds. Another reason for starting with the simple trick is that a beginner usually tries his first tricks on his friends so if they "catch on" to a few it doesn't greatly matter. You can't show the same simple trick too often to the same people without taking a chance that someone will detect it. And, friendly criticism will help you to improve your method before showing it elsewhere.

You are certain to have friends ask you to do a few tricks and it is hard to refuse such a request. So it is often wise to regard a few of your simpler tricks as "expendable" where your friends are concerned. Having granted their early requests, you can politely refuse further appeals to "tell how it's done" when you, yourself, have graduated to more advanced methods. This is strictly in keeping with modern magical procedures for two reasons: First, certain tricks fall into the "puzzle" class, the sort that

keen persons can figure out for themselves if given enough time. Show these as your "starters" and you will gain a receptive audience among the people that you are trying to impress most. Quite a few of these neat "puzzlers" are described in the pages that follow and you will find them very useful when beginning your career as a magician. If people "catch on" to them, so much the better. You can congratulate them on their insight, and then proceed with something subtler that will really leave them guessing.

Second, magic has expanded so greatly during recent years that there are actually hundreds of new tricks coming up annually, compared to mere dozens in times gone by. Long ago, magicians guarded the secrets of some of the simplest tricks, including many that are described in this book, as if the whole art depended on them. But that time has passed. Modern magicians keep ahead of the game by coming up with new mysteries, or adaptations of old ones, so quickly and frequently that the public cannot keep up with them.

With more than a hundred items described in the pages that follow, all easily performed and each baffling, according to its own degree, this book will definitely fulfill its title of *Fell's Official Know-It-All Guide to Magic for Beginners.*

About the Author

Walter B. Gibson, fondly known as the "Magician's Magician," learned magic by practicing with the all-time greats. Over a 35-year period he performed side-by-side with the famous Harry Houdini, Howard Thurston and Harry Blackstone. Mr. Gibson served as president of the Philadelphia Assembly of the Society of American Magicians and held the title of first vice president of the Magician's Guild of America.

Not only was he a prolific writer in the areas of magic, hobbies, psychic phenomena, games and puzzles, he also created and wrote scripts for over 2500 episodes of radio's most famous thriller, *The Shadow*. And, under the pen-name of Maxwell Grant, he wrote over 300 novels.

When not performing, the legendary magician enjoyed residing in his 22-room "haunted-house" in Eddyville, New York.

ABOUT THE EDITOR

Mike Shelley has been performing magic for over 40 years and has been involved in all phases of magic. He is the International Deputy of the Society of American Magicians; chairman of the International Brotherhood of Magician's Dealer Committee; president of the Society of American Magicians #76; past president of both the Florida State Magician's Association and Ring 150, SAM Assemblies 100 and 49; and past vice president of the Magic Dealers Association.

As an author, he has written a column for *Magic Manuscript* and has been published in Harry Lorayne's *Apocalypse* and Jerry Sadowitz's *The Crimp*. He was a featured lecturer at the 1999 International Brotherhood of Magician's Convention, has spoken at the Magic Castle, and has appeared at magic conventions throughout the world. As the owner of All Decked Out, he has invented over 200 tricks in Mentalism, Close-Up Magic, and Platform and Stage Magic.

How to Set Up Your Own Magic Show

he primary rule, established long ago, for planning or setting up a magic show is this: the beginner must gain his experience in magic by actually performing it. But, you must not start doing your tricks in a haphazard fashion. You must create a routine or program where one trick demands that another follow. Consequently, the opening trick becomes the prime factor in any program and should be given due consideration.

The purpose of the opening trick is to arouse immediate interest. It should, therefore, be a trick that can be done smoothly and rapidly, with NO chance of going wrong. Because there are many tricks that meet this qualification, choose the one that you like the best and find the easiest to perform. Any hesitancy or failure in the opening of your show may slow the tempo of your entire act.

Don't worry about your first trick seeming to be too easy; simplicity will not slow you down. You will immediately follow it up with a trick that is a little more baffling. In fact, your show should "build" in interest as you go along.

However, do not overlook the value of the surprise element when selecting your opening trick. A quick trick with an odd finish—even one with a touch of comedy—will always put your audience in the mood to see more. This is important in the early stages of your program. From your first trick on, there are two important rules to remember: make your show long enough to satisfy your audience, and always leave them wanting more.

This means that the body of your program must consist of a variety of tricks; you want your audience to keep wondering what to expect next. It is all right to follow one trick with something of a similar nature, provided that the later trick tops the earlier one in some special feature. Often, people want to see you do a certain trick again; if you have a follow-up that provides an added twist, you will not only meet their request, but you will leave them even more baffled.

During the middle section of your program, introduce some tricks that are slightly more complex, but don't overdo it. One important piece of advice seldom given to beginners is that it is important to have one or two tricks in reserve that can be injected into your program should it seem to lag. Usually beginners fall back on a set routine that works if everything is going well. But, if the audience starts becoming bored or indifferent, you may find yourself just muddling through your act. This is the time when you can afford to eliminate a slow or complex trick and shorten your program with a few "quickies" that you have in reserve. Make sure you do have a reserve.

This, of course, marks the finish of the show, so top it off with the trick that you like the best and are able to perform most proficiently. Remember, this trick should be fashioned for your immediate audience. The ultimate purpose of every performance is to make your audience happy. It may take you a few shows before you find out just which trick should be reserved for the climax; you may wind up by taking something from the middle and putting it at the end. How you decide on this trick is fairly simple; just keep thinking in terms of audience appeal. Whichever trick people seem to like best will make the best climax.

Remember, audience tastes vary, so a good climax for one group might not be the best for another. This, in turn, brings you the choice of programs that most beginners can put into one of the following types:

Card Magic

Particularly suited for card players or people at least familiar with playing cards. Men often like dealing tricks of the gambling type, so keep that in mind. In many cases you will find that such effects will make the ideal finish for your show.

General Magic

Rather than just doing coin tricks, string tricks, and so on, it is better to mix these. Work with a few coins first, then bring out a length of string and go through a routine with it. Finish with a borrowed handkerchief. Or, switch from one to the other, if you prefer, putting the string aside and bringing it out again later. This type of show can be very artful, as you can secretly drop a coin into your pocket when going into it for something else, or switch one item for another. Keep the rule of a quick opener and a strong climax firmly in mind with this type of show.

Table Magic

This is the easiest type of show in one sense as you are limited in scope and must therefore follow a somewhat regular pattern. Here, too, it is important to remember to set up an upcoming trick without the audience realizing it.

Mental Magic

This is in a class by itself. Even beginners realize that if they perform mental tricks only, they may have a startling impact on the audience. When people think that you are really making predictions or displaying snatches of ESP, they are apt to be both disappointed and disillusioned if you begin by doing juggling feats or bits of hanky-panky. So stay in the mood the audience wants most. And, stick with your rule of a catchy opening, good routines to follow and a smash climax. Then, you just can't go wrong. Incidentally, there are some tricks in other sections—particularly among Card Tricks—that can easily be adapted to a program of Mental Magic if needed.

Similarly, it is all right to drop a good mental trick into a program of other types: **Card Magic, General Magic, Table Magic.** There may be times when you'll find it advantageous to mix the whole lot, switching from one to the other as you choose. It's a good way to sound out audience reactions in order to shape your programs accordingly after you have passed the beginner's stage.

Part I

Instant Magician
Featuring Over-Easy Card Tricks

POOF! You are now an instant magician. Wasn't that easy? Well, so are all of the tricks that are in this chapter. All you need for these mysteries is a deck of cards, a glass and a handkerchief. Though all the tricks are simple, they represent a variety of effects, enabling the beginner to follow one after the other in steady succession. This means that before your audience has a chance to guess how a trick is done, they will find themselves outguessed by the next. This makes it all the more difficult for people to think back to those they witnessed earlier. All this works to the beginner's advantage.

A Magic Discovery

You Gotta Have a Gimmick
a deck of playing cards prepared as discussed

How the Trick Appears:
The magician lays a deck of cards face down on the table and asks someone to cut it into two piles. He then turns his back and tells the person who cut the deck to think of a number

not higher than thirteen, and to deal that many cards from the lower half of the deck to the upper half. The person is then told to place the remaining cards in the upper half of the deck upon the lower.

The magician turns back around and rapidly counts cards from the top of the deck, without looking at a single card. Suddenly he tosses a card face up—and the spots on the card tell the number of cards moved!

For instance, the audience member takes the deck and cuts it. He deals six cards from the lower half to the upper. He places the top portion of the deck upon the lower; the magician takes the deck, deals and turns up a six spot. Jacks signify eleven; Queens twelve; Kings thirteen.

Do all the secret setup in advance where no one else can see you doing it.

The Secret:

2

1. This is a trick that works itself. Arrange thirteen cards on top of the deck: King, Queen, down to Ace, which is the lowest of the arranged cards. Suits are optional; hence you can quickly make this arrangement with a borrowed deck.

2. Let the audience member cut the deck and deal cards from the bottom pile to the top, then replace the top pile on the lower.

3. All you have to do is count down to the fourteenth card and turn it face up. It will reveal the number of cards moved.

4. Suppose three cards were moved; it is then advisable to replace the cards you dealt and count off three, putting them back in the lower portion of the deck. You will then be able to repeat the trick. Do not repeat it too often, however, and shuffle the cards when you are through. It is wise to have a Joker under the Ace in your setup; then, if no cards are moved, you turn up the Joker, which signifies nothing.

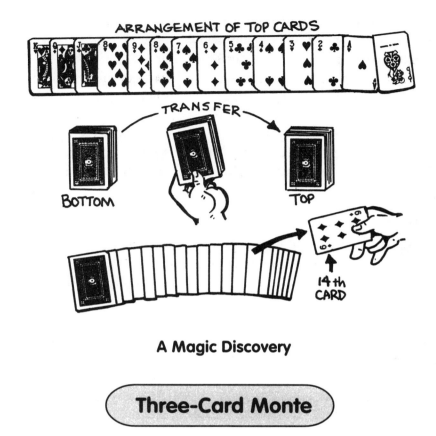

ARRANGEMENT OF TOP CARDS

TRANSFER

BOTTOM TOP

14th
CARD

3

A Magic Discovery

Three-Card Monte

You Gotta Have a Gimmick
three spot cards and the corner of a picture card

Everyone has heard of the Three-Card Monte trick in which the magician shows a Queen and two other cards, lays them face down, and asks an audience member to pick the Queen. It's always hard to get the Queen.

How the Trick Appears:
Here's a form of the trick that will fool them all and is very easy to do. The magician takes three cards from any pack and

carefully arranges them with the Queen in the center. Then he flings the cards face down on the table, but no one can pick the Queen. He can give them two guesses—and then three—but they won't find the Queen. It isn't there; it's in the magician's pocket!

The Secret:

1. Take an old card—a Queen of Hearts—and cut off a corner. Carry this corner-piece with you. When you are ready to do the trick, take any deck, and turn your back while you arrange the cards.

2. First find the real Queen of Hearts and slip your corner-piece in the fan in front of the center card. Now you can show the fan back and front, holding it in your right hand.

3. There are three cards front and three cards back; but the corner-piece that registers Queen of Hearts hides the real center card of the fan. Turn the fan down and grip the spread end of the fan between the thumb and fingers of the left hand as though to arrange the cards.

4. Draw the right hand rapidly away, throwing the three cards face down on the table. The left fingers and the thumb hold on to the little corner-piece, which is easily concealed by the fingers, as it is quite small.

5. Of course none of the three cards is the Queen, and you bring the Queen from the pocket, leaving the little corner-piece there.

6. There are many different versions of this trick. There are all sorts of gimmicked cards that are available from your favorite dealer (see back of book for complete list) to enable you to do this effect. They are all available by asking for Three Card Monte Effects.

4

Three Card Monte was first mentioned in 1861 in Robert-Houdini's **Card Shaping Exposed.** *This same trick, using sleight of hand, has become a con game and is played on street corners all over the world.*

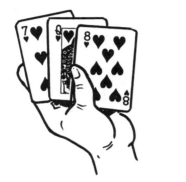

5

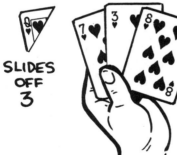

SLIDES
OFF
3

NOTE THE REMOVAL
OF THE LITTLE
CORNER.

Three-Card Monte

Find the Card

You Gotta Have a Gimmick
deck of cards

How the Trick Appears:

You can obtain surprising results with this trick. The magician takes a deck of cards and runs through them, holding the deck face down and moving the cards from the left hand to the right. An audience member selects a card; the magician opens the deck slightly and has the card replaced. The deck is cut several times; the magician immediately discovers the chosen card.

The Secret:

1. The secret lies in the use of an old card, or what magicians call a "key card," from another deck. You slip this card into the deck that you are using (which may be borrowed). As you spread the cards, look for the one with the different back.

2. When you come to it, "slide" it quickly, so its back is covered, but hold an opening below it.

3. When an audience member removes a card, lift the deck at the opening so the chosen card goes in at that place. The cutting of the deck is inconsequential; the chosen card will be the card just below the odd card. By running through the deck and looking for the strange card, you can locate the card that was selected.

6

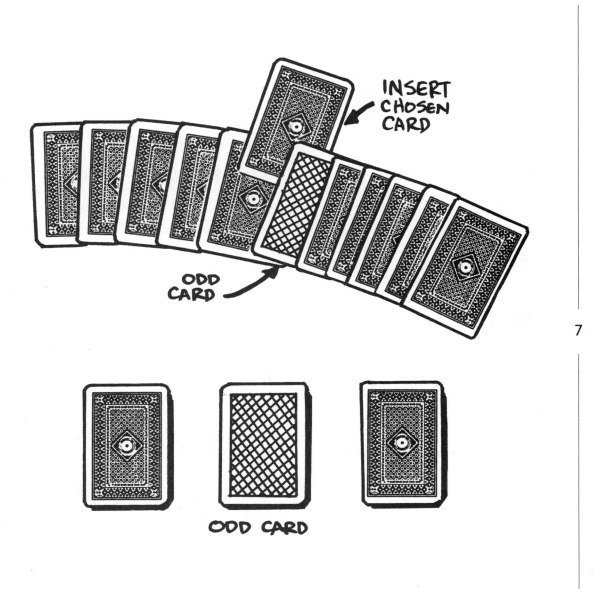

INSERT CHOSEN CARD

ODD CARD

ODD CARD

Find the Card

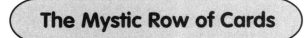

The Mystic Row of Cards

You Gotta Have a Gimmick
a deck of cards prepared as described

How the Trick Appears:
This is another trick of discovery. The magician lays eleven cards in a row, face down, and invites an audience member to move any number of cards from the left end of the row down to the right, moving the cards one at a time. This is done while the magician's back is turned and of course, the audience member can slide the cards back so as to keep the row in its same relative position.

The Secret:

8

1. The cards run from ace to ten, with a joker or blank card at the extreme right. After the cards are moved, turn up the card at the right of the row and you will reveal the number moved—the joker or blank signaling zero.

2. A clever thing about this trick is that you can repeat it immediately by simply putting the card face down and turning your back. No need to rearrange the card. To do this, remember the card you turned up; suppose it was a four. Since you turned up the first card on the right, you must now add four to one, and the next time turn up the fifth card from the right. This will reveal the number moved on the second transfer.

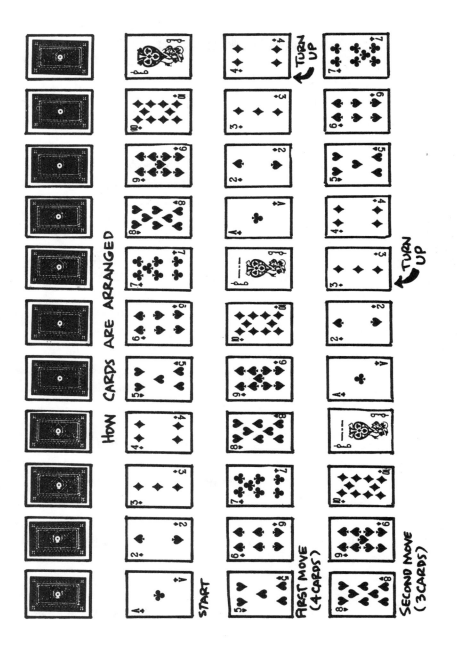

The Mystic Row of Cards

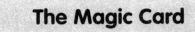

The Magic Card

You Gotta Have a Gimmick

a deck of cards prepared as described

How the Trick Appears:

Six piles are dealt in this trick; a card is taken from one pile and the piles are gathered and cut. Running through the cards the magician discovers the selected one.

The Secret:

1. Pick up a deck and place six cards of one suit on the bottom and six of this same suit on the top. You can do part of this following another trick; if you still have a few cards to arrange you can do it by saying that you are going to remove the four Jacks as they are trouble-makers, and in finding the four Jacks you finish your arrangement. The elimination of the Jacks also disposes of the odd card of your suit, so that there are six Diamonds (for example) on top and six Diamonds on the bottom.

2. Lay the deck down and tell an audience member to deal six piles. As there are just forty-eight cards (Jokers being out with the Jacks), this makes even piles. The top card and the bottom card of each pile will be Diamonds, but no one knows this fact.

3. An audience member takes any pile and removes a card from the middle of that pile, which he remembers. He puts it on top of any other pile and gathers the piles together. You do not have to watch him do this. The deck may be cut. The result is that the selected card is between two Diamonds; when you run through the deck face up you can tell as soon as you see it.

10

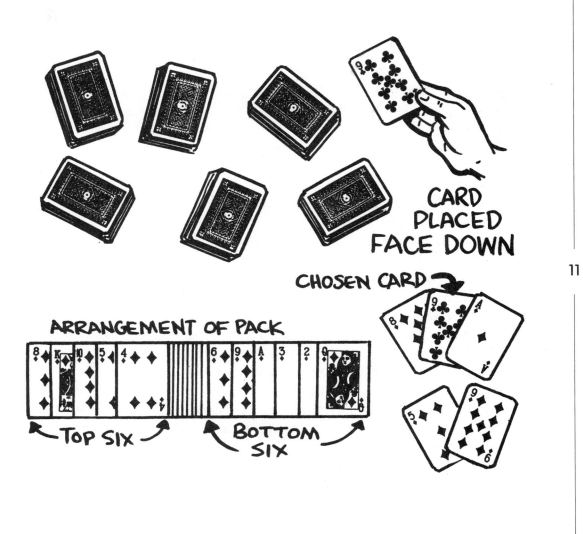

CARD PLACED FACE DOWN

CHOSEN CARD

ARRANGEMENT OF PACK

TOP SIX

BOTTOM SIX

The Magic Card

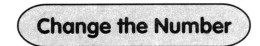

Change the Number

You Gotta Have a Gimmick
a deck of cards in any order

How the Trick Appears:
This is a surprise. An audience member takes the deck and re-members a card—also how far it is from the top of the deck. Another audience member names a number; the magician mixes the deck and puts the first person's card at the spot named by the second!

The Secret:
1. The first audience member notes a card and its number from the top; you specify it must be less than twelve from the top. Suppose he picks the Nine of Hearts—five from the top.

2. The second audience member is told to name a number above twelve aloud. Suppose he says sixteen. You place the deck behind your back and count off sixteen cards one by one, reversing the order, afterward replacing them on top. Reversing the order of cards is what magicians call reverse count.

3. Now comes the clever action. You may say that you have put the mentally selected card at the number named by the second party; that it will now be number sixteen in the deck.

4. You ask the first audience member, "At what position was your card?" He replies it was fifth from the top. You count beginning with five, dealing a card on each count, "five, six, seven," and so on to sixteen. You turn the sixteenth card face up and it is the selected card, the Nine of Hearts.

5. Although this trick is another that works automatically, you should practice it a few times so that you can do it neatly and without too much delay.

> *A good magician never tells how a trick is done. What keeps magic alive is the secrets.*

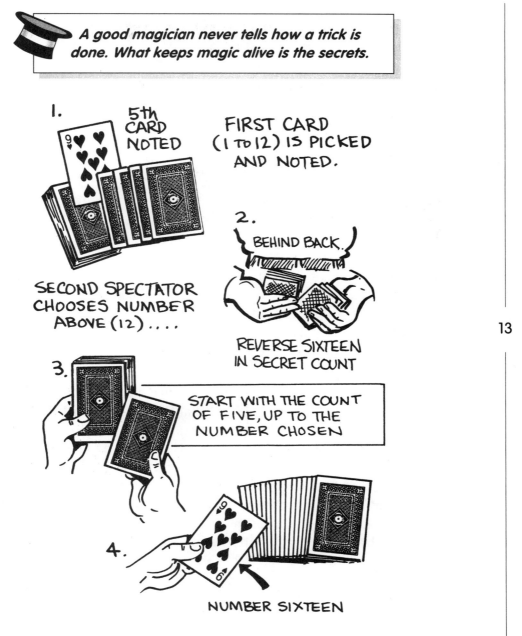

1. 5th CARD NOTED

FIRST CARD (1 TO 12) IS PICKED AND NOTED.

SECOND SPECTATOR CHOOSES NUMBER ABOVE (12)

2. BEHIND BACK

REVERSE SIXTEEN IN SECRET COUNT

3.

START WITH THE COUNT OF FIVE, UP TO THE NUMBER CHOSEN

4.

NUMBER SIXTEEN

Change the Number

13

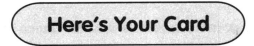

You Gotta Have a Gimmick
a deck of cards plus one card with an odd back and different back design

How the Trick Appears:

The magician instructs an audience member to shuffle the deck and to deal off a small number of cards in a column, turning them face up so they overlap. The person must remember the last card dealt—also its order in the deck. Suppose he deals eight cards and the final card is the Six of Clubs; he remembers Six of Clubs and the number eight. This, of course, is done while the magician's back is turned, so he doesn't know the card or its order in the deck. The cards are replaced on the top of the deck.

The magician puts the deck behind his back and the audience hears him counting as though he is trying to find the card. Then he tells the audience that he is mixing the cards.

He then gives the deck back to the audience member and tells him to deal off the same number he dealt before (that means eight in this case, but, of course, the magician does not know this number) and tells the audience member to watch for his card. He does not see his card, so the magician tells him to gather up the cards he dealt and put them on the bottom of the deck.

Once more the magician puts the deck behind his back and the audience hears him counting as though he is trying to find the card. He tells the audience that he is mixing the cards.

The magician gives the deck to the audience member and tells him to deal off the same number he dealt before (that means eight in this case, but the magician does not know the number), and tells him to watch for his card. He does not see his card, so the magician tells him to gather up the cards he dealt and put them on the bottom of the deck.

Once more the magician puts the deck behind his back and moves some cards. Then he lays the deck on the table, and suddenly turns the cards face up. The chosen card is staring at him from the bottom of the deck!

The Secret:

1. It doesn't matter how many cards the audience member deals or what card he chooses. He must simply follow your directions and remember the last card on his first deal.

2. Behind your back you move fifteen cards from the top of the deck to the bottom. The second time you put the cards behind your back, you move fifteen from the bottom of the deck to the top.

3. The first move keeps the audience member from seeing his card on his second deal; the second move puts his card on the bottom of the deck. Try it!

15

Let your audience know when the magic is happening by having them say "the magic word" or by waving a magic wand, etc.

16

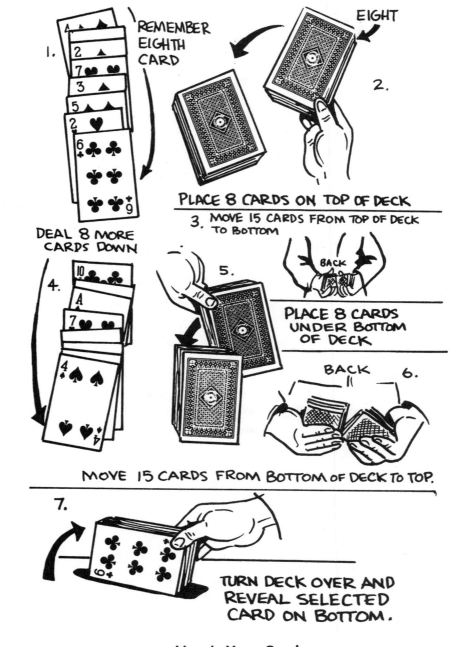

1. REMEMBER EIGHTH CARD

EIGHT

2.

PLACE 8 CARDS ON TOP OF DECK

3. MOVE 15 CARDS FROM TOP OF DECK TO BOTTOM

DEAL 8 MORE CARDS DOWN

4.

5.

BACK

PLACE 8 CARDS UNDER BOTTOM OF DECK

BACK 6.

MOVE 15 CARDS FROM BOTTOM OF DECK TO TOP.

7.

TURN DECK OVER AND REVEAL SELECTED CARD ON BOTTOM.

Here's Your Card

The Sharper's Trick

You Gotta Have a Gimmick
a deck of cards

How the Trick Appears:
This is a trick used as a joke on your audience. To do it, the magician must first be able to discover a chosen card. Hence it is a good finish for the "Magic Card" trick just described; it can also follow "Find the Card" or "Here's Your Card."

The effect of the trick is very clever. The magician holds the deck face down and deals cards one by one, face up. Finally he stops and says, "The next card I turn over will be your card."

The joke seems to be on the magician because he has already passed the chosen card; it is lying among those that are face up. Lots of people will bet that the magician is wrong, but he is actually right.

17

The Secret:
1. Instead of turning the top card of the deck face up, reach out, pick up the chosen card and turn it face down!

2. Of course, the method is simple; you actually knew the chosen card but passed it intentionally just to turn the joke on your friends.

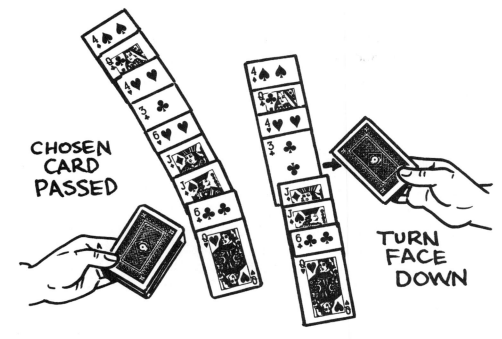

CHOSEN CARD PASSED

TURN FACE DOWN

18

The Sharper's Trick

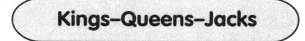

Kings–Queens–Jacks

You Gotta Have a Gimmick
4 Kings, 4 Queens, and 4 Jacks prepared as described

How the Trick Appears:
The magician takes the Kings, Queens and Jacks from a deck and lays them in three rows of four cards each—every card face up. Then he gathers the cards rapidly and lays them face down— anyone can cut the deck. When he deals in piles, all Hearts are together, as are Spades, Clubs and Diamonds.

The magician's second row begins with the last card of the top row; then it follows the order of the top row—that is, in this instance: Heart, Spade, Diamond, Club. The bottom row begins with the last card of the

second row, then follows the order of the second row—in this case: Club, Heart, Spade, Diamond.

The Secret:

1. In laying out the cards, make sure all four suits are in the top row—suppose cards run Spade, Diamond, Club, Heart.

2. When you gather the cards, pick them up in vertical columns instead of horizontal rows, beginning with the bottom card on the right. Pick up the card in the lower right corner and lay it on the card above it. Lay both of these cards on the card above them, and then lay all three of these cards on the bottom of card of the next vertical column, and so on. The packet can be cut after you turn the cards face down. That doesn't interfere at all; when you deal four piles you automatically separate the suits.

3. With a little practice you can lay these cards out quickly and easily. You don't have to worry about values; just watch the suits. The trick then works automatically.

19

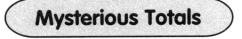

Mysterious Totals

You Gotta Have a Gimmick
a deck of 52 cards

How the Trick Appears:
An audience member takes a full deck of 52 cards and deals three cards face up on the table. He notes the value of the first card, suppose it is a six, and deals cards face down upon it to bring the count to fifteen. Thus nine cards would be required in addition to the six spot.

He does the same with each of the remaining cards. Suppose one is a ten spot—the person calls that "ten" and deals five cards upon it, counting "eleven, twelve, thirteen, fourteen, fifteen." If the third card is an eight, he must deal seven cards on top of it to reach the required total of fifteen.

An ace counts as one; if an ace is dealt, fourteen cards are required in addition (all picture cards count as ten). Suits have nothing to do with the trick.

All this takes place while the magician is away. He returns after the deal is made and picks up what is left of the deck. He deals these cards rapidly and then names a number, in this case twenty-four. That number is the total of three cards that are on the bottom of the pile!

The Secret:

1. The cards that are left over tell the tale of the trick. When counting them, disregard the first four, but count all others.

2. They will give the total of the bottom cards of the three piles.

3. With twenty-eight cards left over, four are ignored; the rest are counted and the total of twenty-four is obtained.

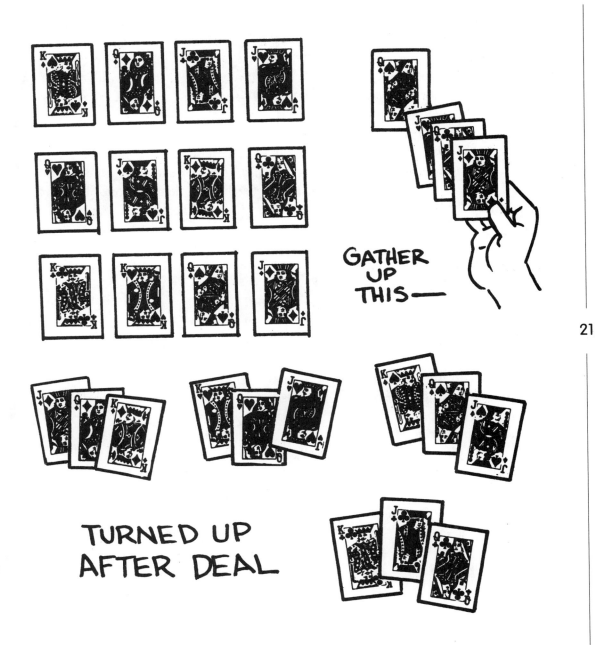

GATHER
UP
THIS—

TURNED UP
AFTER DEAL

Mysterious Totals

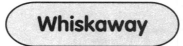

Whiskaway

You Gotta Have a Gimmick
a deck of cards, a tumbler and a handkerchief

How the Trick Appears:

After spreading a deck of cards on the table, the magician picks one up and puts it in a drinking glass so that everyone can see the face of the card. He drops the handkerchief over the card, and suddenly whisks away the handkerchief. The card is entirely different! He immediately passes the glass, the card and the handkerchief around the audience for examination; a Four of Clubs has changed to an Eight of Diamonds before their eyes!

The Secret:

1. The first step in this trick is to pick up two cards together, holding them at the sides and bending them slightly forward in the center so that they appear to be one card. Any two cards will do; we will suppose that the Eight of Diamonds is hidden behind the Four of Clubs.

2. Once the two cards are put in the glass, they remain together very nicely and the glass can be shown on all sides. You simply place the handkerchief over the glass and, through the cloth, you separate the two cards that are now hidden from sight.

3. When you whisk away the handkerchief, you grip the front card (Four of Clubs) through the cloth and draw it away with your right hand, the left holding the glass.

4. Immediately lower the handkerchief to the table and tilt your right hand. Drop the Four of Clubs from the handkerchief so it falls face down on top of the deck. This permits you to pass the card, glass and handkerchief for inspection. When everything can be given out for inspection you end clean.

22

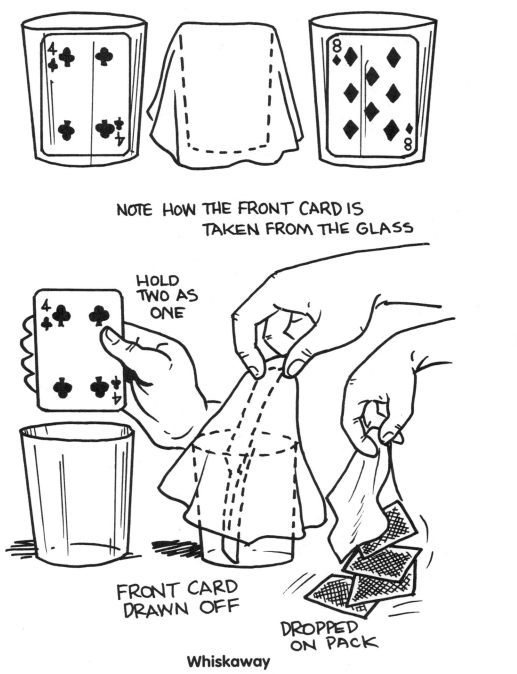

NOTE HOW THE FRONT CARD IS
TAKEN FROM THE GLASS

HOLD
TWO AS
ONE

FRONT CARD
DRAWN OFF

DROPPED
ON PACK

Whiskaway

THREE KINGS AND
AN ACE

KINGS!
TOP CENTER
BOTTOM

KINGS AND ACES TOGETHER!

ON TOP
OF
PACK

Mysterious Kings

Mysterious Kings

You Gotta Have a Gimmick
a deck of cards

How the Trick Appears:

Three Kings are removed from the deck, along with the Ace of Spades. The magician places one King on the top of the deck; one King in the center of the deck; and the third King on the bottom of the deck. All three Kings are separated.

Next the magician puts the Ace of Spades on top of the deck, as it possesses a magnetic power that causes cards to come together. The magician cuts the deck and lets an audience member cut it two or three times (all single cuts). Then the magician snaps the cards and runs them face up along the table only to find the Ace of Spades among the three Kings!

This is a real puzzler and no one suspects the simple method that is used. The top King and the bottom King come together with the Ace of Spades when the deck is cut. But what about the third King buried in the center of the deck? How does it end up with the others?

The Secret:

1. It doesn't end up there at all. When you remove three Kings and the Ace of Spades from the deck, covertly slip the odd King (the fourth one) on the top of the pack. Hence it is with the other two Kings and the Ace at the finish. No one remembers just which three Kings were used, and they take it for granted the third King which appears in the group was the one you buried in the deck.

This is the second ending of a trick with two endings.

25

The Card Circle

You Gotta Have a Gimmick
a deck of cards

How the Trick Appears:

A deck of cards is shuffled by a member of the audience. The magician takes the deck and divides it into four face down piles. Three piles are on the table with one in his hand. He asks three audience members to each take one card from a different pile. Each person is to look at his card and hold onto it.

Then the magician gives the deck to another audience member and tells him to deal three piles, stopping when he likes, just as long as he puts the same number of cards in each pile. He can deal three piles of five cards each, or piles of seven cards, or whatever number his fancy may dictate.

The magician turns away during this process and tells the audience members who are holding chosen cards to replace their cards on the three piles which have been dealt, each person placing his card on a different pile from the others. The magician may watch this to make sure that instructions are followed.

Now the three piles are gathered and the pile is cut by any member or members of the audience. Then, the magician deals a circle of cards, using all cards in the pile. Running around the circle he discovers the three chosen cards.

The Secret:

1. To do the trick, you must first note the top card of the deck. You do this when you divide the deck into four piles, the smallest of which is in your hand. As you ask each audience member to lift one card of the three decks on the table, you

illustrate this by lifting the top card of those in your hand, thus enabling you a glance at the card.

3. After three cards have been taken, gather up the deck, leaving your top card, which we will suppose is the Queen of Hearts, on top of the deck. So, when the next set of three piles is dealt face down, your "key" card is the bottom card of one of the piles.

4. The chosen cards are replaced on the piles, the piles are gathered and the group of cards is cut.

5. Deal the circle, just as though you were going around a clock-dial (perhaps clockwise would be simpler).

6. As you deal, count the cards, and divide the total by three. For instance, when you deal twenty-four cards, you obtain eight by dividing. This means that every eighth card will be one of the selected cards.

27

7. Next, look for your key card, which we said earlier is the Queen of Hearts. The card following the key card will always be the one which happens to be on top of the deck.

8. The number of cards in the circle will vary. But you can always find the positions of the chosen cards by dividing the total of cards dealt by three. The first chosen card will always follow your key card.

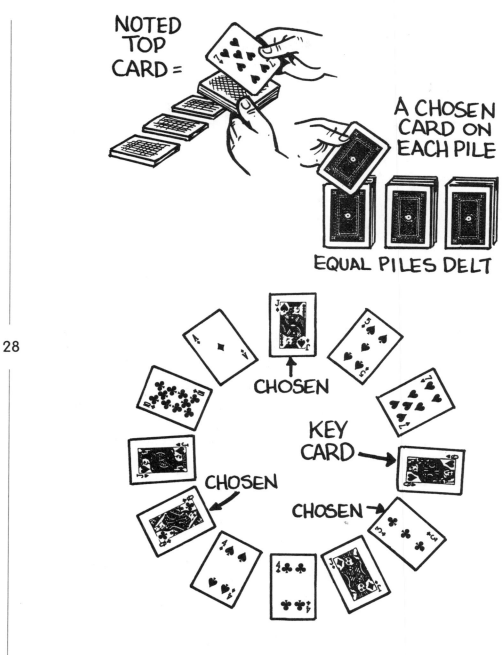

28

The Card Circle

Quick Poker Deal

You Gotta Have a Gimmick
a deck of cards prepared as described

How the Trick Appears:

For a quick, effective poker deal, this simply can't be beaten. After shuffling a deck, the magician offers to show how gamblers set up "big hands" for themselves, particularly in a game like poker. Assuming that there are five players in a game, the magician deals five hands of five cards each, one at a time, as is customary in poker, all hands face down.

Turning up each hand, he shows that nobody was dealt anything very good. One may have a Pair, as Two Eights, another Two Pairs as Jacks over Fives, or even Three of a Kind, but the rest of the hands look pretty feeble. That, however, doesn't bother a smart gambler. When he picks up discarded hands, he sets them for the next deal, so saying, the magician gathers the hands in any order and deals another round.

This time, the first four hands are poor as usual, but when he comes to the last hand, his own, the magician proves that he is as skilled as any gambler. The cards he turns up are the Ace, King, Queen, Jack and Ten of Hearts, which form a Royal Flush, the best possible hand in the grand old game of poker!

The Secret:

1. Before starting the trick, run through the deck face up and slide the five highest Hearts to the top. You can rifle shuffle the deck, making sure to keep these five on top; then deal your first round. Each hand will have one of your high Hearts on the front, but no one will notice that, as they are looking for Pairs and other combinations.

2. Gather the hands in any order, turn them face down and deal your next round. Every fifth card will arrive in your hand, giving you the Royal Flush.

29

Four Ace Deal

You Gotta Have a Gimmick
a deck of cards prepared as described

How the Trick Appears:

In this intriguing effect, the magician asks an audience member to name a number from ten to twenty; the magician deals that number of cards from the deck, say "15," onto the table. He then states that he will add the two figures forming the chosen number, in this case $1 + 5 = 6$, and deals that many cards from the pile on the table onto the deck. The magician carefully lays the next card to one side, face down, and places the pile back on the top of the deck. This process is repeated with three other people, each of whom has the same free choice of number.

The magician finally turns up the four cards that he dealt aside and to everyone's surprise, they prove to be the four Aces, elevating the trick into the class of an expert poker deal!

The Secret:

1. Actually, the trick works automatically. Set the deck beforehand with the four Aces at positions 9, 10, 11 and 12 from the top of the deck and the Aces will be the cards that you lay aside regardless of which numbers are chosen, provided that they are from 10 to 19 inclusive.

2. When moving the sum of the digits (in this case, six) from the table back to the top of the deck, each card must be dealt on top of the previous card, reversing the order in each count. The total of the digits merely counteracts the original number.

30

Eleven Speller

You Gotta Have a Gimmick
the eleven cards as described

> *For an automatic baffler, this effect deserves top rating. It can be performed with any deck, and the simple setup required makes it ideal as an "opener" for a card routine, or as an interlude between other tricks. Its subtle secret allows it to be repeated. By switching to a similar routine with a different setup, the audience can be thrown off the trail completely.*

How the Trick Appears:
From a face down deck, the magician counts off a batch of cards—from ten to a dozen—and asks an audience member to shuffle them. That done, he is instructed to deal them into two equal piles. If there is an odd card left over, he is to look at it and place it between the piles. The magician then takes the original face down deck, and when the audience member names his card, the magician spells it letter by letter. The magician then turns up the final card and it proves to be the very card that was originally chosen—for example, the Ace of Hearts.

The Secret:
1. For this sure-fire effect, you need eleven cards with names that are spelled with eleven letters. There are eleven such cards available in a deck of cards: Four of Clubs, Five of Clubs, Nine of Clubs, Jack of Clubs, King of Clubs, Ace of Hearts, Six of Hearts, Ten of Hearts, Ace of Spades, Ten of Spades, and Six of Spades.

2. Mix these eleven cards and turn them face down, forming a small pile which you then place on the top of the deck. Put the deck in the Card Case, or simply have it lying handy on the table.

3. State that you will perform a mental mystery using ten to twelve cards. Deal your eleven cards face down from the top of the deck, counting them to yourself, and tell an audience member to shuffle them face down.

4. Instruct the audience member to deal the shuffled cards into two equal piles—a card to the left, a card to the right, and so on. Turn your back while he is doing this and add, "If you have an odd card left over, hold it and tell me." The audience member deals as directed.

5. Since he has an odd card, he says so. Keeping your back turned, tell him to look at it, remember it, and place it face down on either pile; then put the other pile on top. He looks at the card, in this case, the Ace of Hearts.

6. While he is placing the card between the piles, turn toward him and tell him to square the entire deck and hand it to you. He, of course, does this.

7. Taking the deck, you say: "Name your card and I will spell it, by dealing a card for each letter and keeping the next card for myself." He says, "Ace of Hearts," and you deal the top card face down on the table, spelling: "A" — Make your tone emphatic.

8. You draw off the next card and move it to the bottom of the deck, quietly remarking, "And this one, I keep." This will adhere to your statement.

9. Deal off the next card, spelling "C" in an emphatic tone, as you place it face down on the "A" card that you dealt to start.

10. Move the next card from the top of the deck to the bottom, remarking quietly, "Another for me." Continue the spelling process, naming the letters aloud, but from here on, you simply move the alternate cards to the bottom without comment. In this way, spell the full name of the card: A*C*E*O*F*H*E*A*R*T*S (the letters represent cards dealt; the stars are cards moved under). When you come to "T" you have just one face down card in your left hand. So, you call it "S" and place it in your right hand.

11. You then announce "Ace of Hearts!" With your right hand, take the remaining card and extend it to the audience member saying, "That was the odd card you took!" Turn it up as he reaches for it and he will find himself holding the very card you spelled.

In this trick, always use the same eleven cards. Since eleven really is the number between "10 and 12" and the audience member is sure to have an odd card to look at, the trick will automatically work. No matter which card of the group is spelled, it will turn up at the finish. Hence, another audience member can shuffle the pile and you can repeat the trick immediately. As you proceed, you can even let an audience member do everything himself, even spelling the name of the card mentally, letter by letter, without naming his card aloud until down to the last one, which turns out to be it. In this case, make sure that the audience member follows the dealing process exactly.

Lucky Dozen

You Gotta Have a Gimmick

12 cards as described

> *Here is another mental mystery that matches the effect of the trick of the Eleven Speller. The procedure is so similar that most people will suppose that the two tricks are one and the same, which is all to the magician's advantage, as the difference is actually enough to throw keen audience members off the trail.*

34

How the Trick Appears:

A dozen cards are taken from the full deck, shuffled face down and then dealt into three separate piles. An audience member notes the bottom card of any pile and places that pile between the other two. Cards are dealt, spelling the name of the chosen card, which turns up at the very finish.

The Secret:

1. Use the following cards to make up the deck: Three of Clubs, Seven of Clubs, Eight of Clubs, Four of Hearts, Five of Hearts, Nine of Hearts, Jack of Hearts, King of Hearts, Five of Spades, Nine of Spades, Jack of Spades, King of Spades.

2. Mix them and place them on top of the deck so they can be dealt when needed.

3. Deal the dozen cards face down and tell an audience member to shuffle them and deal three equal piles of his own, all face down. This gives him three piles of four cards each.

4. Have the audience member take any pile and turn its face toward him so he can remember the bottom card, say, the King of Hearts.

5. Tell him to place his pile between the other two; he has full choice of which goes above or below. He then gives you the deck.

6. After asking the name of his card, you deal the top card on the table to represent the first letter, in this case "K" in the name "King of Hearts," which you spell out completely. However, like the "Eleven Speller" trick, after every card you place down for each letter, you must place the following card on the bottom of the deck.

7. When you complete the spelling, you will have just one card remaining face down in your left hand.

8. Announce "King of Hearts" and hand the final card to the audience member, turning it face up as you do so. He will find himself holding the very card he noted!

35

This is an excellent companion trick to the "Eleven Speller" because you can use a new group of cards, making it seem all the less likely that you are depending on a setup. You have your deck setup just below the eleven setup, ready for action when needed. You can have an audience member deal the 12-packet into two piles, as he did with the eleven, only to find that he doesn't have an odd card left over. So you tell him to gather the cards, shuffle them again and deal them into three piles. When you come out even, you say you will treat an odd pile just as you would an odd card, so you proceed as described. You can also combine the two tricks very effectively as follows: Give each audience member a packet—one with eleven cards, the other with twelve—and work with both of them together. The fact that each has a different number of cards makes it seem as though you are merely suggesting the ways that they should deal, so that it has no real bearing on the result. By having each audience member spell out his card mentally, this can build up to a double climax where both cards are turned up at once.

Part II

King of the Hill

Tricks for the Story Teller

Tricks involving a story or the solving of a problem will make a strong first impression on an audience, particularly when audience members are invited to "try it for themselves" after the magician has completed his routine. The story itself often misdirects attention from the action, thus puzzling the audience all the more. The term "puzzle" is highly appropriate in this case, since the tricks in this section are actually puzzles that can be demonstrated as tricks. It should be noted that many of these puzzles are similar to each other. Each trick is followed by another that is more baffling, thus leaving the audience totally perplexed—an ideal procedure for the beginner.

Cross the River

You Gotta Have a Gimmick
any Ace, Three, Five and King

How the Trick Appears:
For a puzzle that can be demonstrated as a trick, this one is very simple, but it serves as a pattern for others of a similar nature that can prove baffling. By using it as a lead into more complex tricks, you can put people in the right mood for whatever follows.

The puzzle involves a man who owned a fox, a goose and a sack of corn. He had them with him when he came to a river, where he found a tiny boat just large enough to accommodate him and one of his three charges. He didn't mind leaving one alone while he ferried another across or came back to pick one up, but if he left the fox and the goose together, the fox would eat the goose. And, if he left the goose with the corn, the goose would eat the corn. How did he get them across?

To show how he did it, deal three cards in a column near the left side of the table: An Ace for the fox, a Three for the goose and a Five for the corn. Place a King to stand for the man, while the space to the right can represent the river. No extra card is needed for the boat, as the simple act of moving the King back and forth indicates the man is in the boat. Proceed with your story, demonstrating it with cards: The man takes the goose across, leaving the fox with the sack of corn (take the King and Three together and slide them over to the right). The man then came back alone (bring the King back alone). Next he took over the sack of corn (move the King and Five over to the right). And then he brought back the goose (bring the King and Three back together). Then he took the fox (move the Ace and King) and he returned alone (bring the King back). Finally, he took the goose back over (move the King and the Three) across the river.

> **This trick is intriguing, but easy for the audience to follow and duplicate. You can issue it as a challenge, letting someone else try it first. If they fail, show them how it's done.**

Merchants and Thieves

You Gotta Have a Gimmick
any three Kings and three Jacks

How the Trick Appears:
For this effect you use three Kings, regardless of suit, to represent three merchants, and three Jacks to represent thieves.

You explain that the six are traveling together and that they have to cross a river in a boat just big enough for two. The merchants have learned that their companions are thieves and, while they feel safe as long as their numbers are equal, they do not want to be outnumbered at any time. This means that at no time can a merchant be alone with two thieves, nor will it be safe for two merchants to find themselves in the company of three thieves. How did they do it?

Placing all six cards at the left side of the table, you take two Jacks and move them over to the right, saying, "First, the merchants send two thieves across in the boat (move two Jacks across the river), but one of the thieves has to bring the boat back (bring one Jack back over). Again, two thieves are sent across the river (move two Jacks across) and one returns with the boat (bring one Jack over). Now two of the merchants cross the stream together, leaving a merchant and a thief (move a pair of Kings from left to right). And, one of the merchants brings back a thief (move a King and a Jack back). This allows the two merchants to cross over together and join the one already there (move two Kings to the right). The merchants send back a thief (move a Jack back) who brings back the remaining thief (move two Jacks over)."

> If you practice these moves, using both hands to speed the process, people will be unable to follow them closely and will have trouble trying to duplicate the process.

39

> *A good magician never repeats a trick for the same audience during the same performance. If you are asked to do the trick again, it means you fooled them and now they want the chance to see how you did the trick. Please don't give them that chance.*

Three Married Couples

You Gotta Have a Gimmick

3 matching Kings and Queens

How the Trick Appears:

Both suits and values are used in this "Crossing the River" sequence, which is worked with three matching Kings and Queens, as King of Diamonds (KD) with the Queen of Diamonds (QD), King of Hearts (KH) with Queen of Hearts (QH), and so on. Each of these represents a married couple. All must cross a river in a boat that will carry only two persons and at no time will any husband allow his wife to be in the presence of another man unless he is also there. This applies both to the boat and the shore.

After stating the terms, place the Kings and Queens in a column at the left. Then move the QD and the QC to the right together, as two wives taking the boat across. The QC returns to the left to bring back the boat. Next, the QC and QH cross together to the right. After the QH comes back with the boat alone, she stays on land with her husband, the KH, and the other two husbands cross. When the husbands land, the KD joins the QD, who is already there. The KC and QC bring the boat back to the starting point. The KC and QC land, joining the KH and QH. The KH gets in the boat with the KC and goes to the right, leaving the QC and QH on the other side. The QD comes back alone and picks up the QC followed by the QH.

Three in a Boat

You Gotta Have a Gimmick

four Kings and four Queens

How the Trick Appears:

In this version of the "Married Couples" there are four such happy pairs, but the boat they use to cross the river is large

enough to carry three persons. Otherwise, the terms are the same: No wife can be in the company of any other man unless her husband is also there.

Arrange the Kings and Queens in a column at the left, in the vertical order: KD and QD, KC and QC, KH and QH, and KS and QS. Begin by having the QD, QC and QH take the boat over to the right. From there, the QH returns to the left alone. The QH then takes over the QS, and the QS returns alone.

Now the KD, KC and KH can all go over to the right, joining their wives on that side of the stream. One couple—say, the KH and QH—returns to the left. Then the same pair crosses to the right, taking the KS along with them, leaving the QS alone at the starting point. The KS returns to the starting point, picks up the QS and completes the crossing.

Right before the KH and QH take the KS across with them, another option becomes available. Alternatively, the KH and KS could go over to the right together, leaving the QH and QS on the left. Then either the QD or QC could cross from right to left, picking up the QH and QS to take them over to the right.

Super Poker Deal

You Gotta Have a Gimmick
a deck of cards arranged as described

How the Trick Appears:
Presented in the style of a story, this deal will bring astonished gasps from veteran poker players, who just won't believe that something so good could come up so soon. You tell a story of how a group of five players sat in a game that just couldn't seem to produce a good hand. By way of a sample, you deal five hands, one card at a time, and turn them up, showing that nobody was dealt anything better than a pair.

One player in the game was named "Honest John" because he could stack a deck without having an inkling of what was going on. So saying, you gather the hands in any order, slap them face down on the deck the way Honest John did, and deal another round of hands, then turn them up just as before.

The first hand was the best they'd seen all evening, a Straight consisting of a Jack, Ten, Nine, Eight, Seven of mixed suits. The second hand was a Flush, which beats a Straight—the Queen, Eight, Seven, Four and Deuce were all the same suit. The third hand topped that with the King of Spades, Clubs and Diamonds, over the Three of Spades and Three of Clubs—a Full House. The

fourth was a hand that most poker players regard as a sure winner—all four Aces—with an odd Five of Spades.

But Honest John still triumphed. When you turn up his hand, you show a King High Straight Flush, consisting of the King, Queen, Jack, Ten, Nine—all the same suit—which beats four Aces.

Don't shuffle the deck unless you can do a convincing false shuffle. Tell your story, doing the deal that illustrates it, then show the hands and gather them in order. Repeat the deal and show each of the final hands deliberately. The contrast between these hands and those shown earlier makes the result seem close to impossible.

To put across this marvel, you must have the deck all set beforehand, but since the routine is done in a casual, storytelling fashion, no one will be ready for what happens. Lay out the hands exactly as described and put the first hand, the Straight, on top of the remaining twenty-seven cards. Above that, put the Flush, then the Full House, then the Four Aces with their odd card and, finally, the King High Straight Flush.

42

Honest John Returns

You Gotta Have a Gimmick
a deck of cards arranged as described

How the Trick Appears:
Here is another "Honest John" story that starts out like a full-fledged explanation of gamblers and their methods, only to finish with a real surprise. You start by shuffling the deck

and then explain how Honest John used to run through the cards and slip some good ones into the bottom of the deck, like the four Kings. Then, during his regular deal, he would deal the Kings from the bottom whenever he came to his own hand.

You illustrate this openly by drawing a King from the bottom, serving as a fifth card, so that your hand—which represents Honest John's—gets the Four Kings. Since there is one more card to go, you simply deal it normally from the top on the last round. You then turn up the hands to show that you dealt yourself the Four Kings.

You gather up the first four hands and replace them on top of the deck. Turn the deck face up, then put your Four Kings on the bottom, with the odd card above them. State that this time you will show how smoothly Honest John could deal these Kings from the bottom. Then, for the smash finish, you say, "Honest John didn't really deal those Kings from the bottom." With that, you turn up the bottom of the deck to show the Kings there, as you add, "And why not? Because he didn't need them. While you were watching him closely, he dealt himself four Aces!" Now you turn up the hand that you dealt yourself and there are four Aces with an odd card to complete the hand.

43

The Secret:

1. While you look through the deck to find the four Kings and place them on the bottom for the preliminary deal, you also look for the four Aces and place them on top. This is very easy because you can pretend to have trouble finding the Kings, finally showing them openly, but all the while, you are slipping the Aces to the top of the deck.

2. When you deal the first round, showing everybody how you sneak the Kings out, one by one from the bottom to make up Honest John's hand, you are actually placing all four Aces at the fifth position in each of their four hands.

3. When you place those hands face down on top of the deck, you are all set to deal yourself Four Aces. Try it and you will see!

Part III

You're On Deck

A d v a n c e d C a r d T r i c k s

As card tricks become more complex, they fall into the advanced class found in this section. This is no problem for a beginner; such tricks are actually made to this order. Any complexities pertain chiefly to the "effect" perceived by the audience, rather than the "method" as used by the magician. What the beginner should do is use the experience gained from simpler tricks to "build" these advanced tricks into something more mysterious. Here, handling of the deck itself becomes an important factor. By shuffling and cutting the deck in an easy, convincing fashion (which can be acquired as a matter of course) a magician can soon convince the average audience that skill is important in his work, even though he is baffling people by subtle secrets that they do not expect.

The Mystic Circle

You Gotta Have a Gimmick
ten cards arranged as described

How the Trick Appears:
Ten cards, from Ace to Ten, are laid in clock-like rotation, as illustrated in Figure A. An audience member is told to select a card mentally, and the magician promises to reveal it in a

mysterious way. The audience member is told to point out another card—not the one he selected in his mind—and the magician mentally adds ten to the value of that card. For example, suppose that Eight is the card thought of and Six is the card pointed out. The magician adds ten to six, making sixteen. (See Figure B.)

"Begin at the Six Spot," instructs the magician, "and start to count with the number you selected mentally. Count to yourself as you go around the circle to the left, and stop when you come to sixteen."

The audience member, beginning with Six, starts his count with "Eight." Then he touches the Five and counts "nine," touches the Four and counts "ten," and so on. When he reaches sixteen, the end of the counting, he finds that he is touching the Eight Spot—the card that he selected mentally! (See Figure C.) As the audience member finishes his count, in amazement, the magician smiles and remarks, "That is the card you selected mentally!"

This trick will work every time. If the Five should be mentally chosen, and the Two pointed out, the audience member would be told to count to twelve. He would start his count on the Two Spot, saying "five," and the count of "twelve" would bring him to the Five.

46

The counting is always done counter clockwise. The trick is very easy to do, but baffles those who do not understand it.

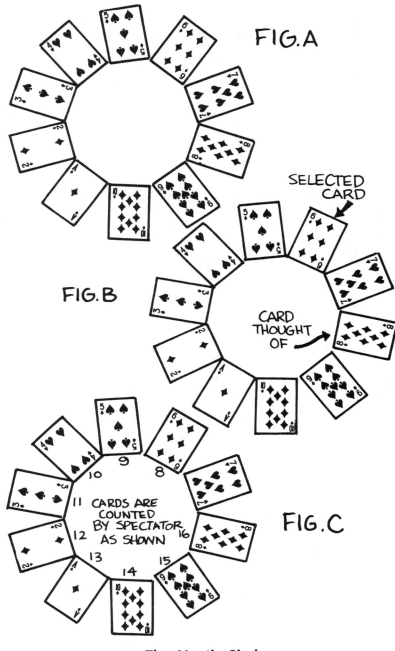

FIG. A

SELECTED
CARD

FIG. B

CARD
THOUGHT
OF

FIG. C

CARDS ARE
COUNTED
BY SPECTATOR
AS SHOWN

The Mystic Circle

The Twenty Card Trick

You Gotta Have a Gimmick
a deck of cards arranged as described

How the Trick Appears:

Twenty cards are selected at random from the deck and are laid in pairs, face up on the table (upper drawing).

Several people are allowed to select any pair mentally. The magician does not even look at the cards closely, but picks them up, and lays them out in a haphazard manner so as to separate the pairs. The cards form four rows of five cards each (lower drawing).

The magician asks a member of the audience to pick out his pair, and to point to the cross-rows in which the two cards appear. The audience member does this and the magician immediately picks up the two cards of the pair. He repeats the discovery with each remaining selected pair.

The Secret:

1. This mystery depends on four Latin words. The magician imagines them spelled out on the table in large letters, thus:

M	U	T	U	S
N	O	M	E	N
D	E	D	I	T
C	O	C	I	S

2. In dealing, he gathers up the pairs into a pile and deals the first two cards on the imaginary M—the M in Mutus, and the M in Nomen. The next two go on the imaginary letters U; the next two on T; two on S; two on N; two on O; two on E; two on D; two on I; and two on C. This appears to be haphazard, but it is not. If a person says that his cards appear in rows 1 and 2, they can only be on letters M; if they appear in row 4, they can only be on letters C; and so on.

48

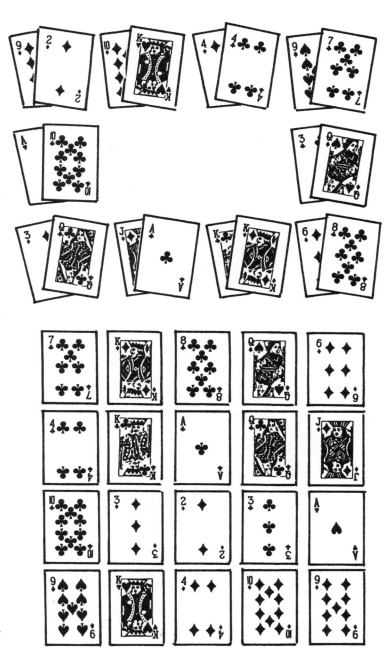

The Twenty Card Trick

Three Columns

You Gotta Have a Gimmick
a deck of cards arranged as described

This is a clever divination trick based on a simple formula. It perplexes the audience, and makes them sure there is not a system.

How the Trick Appears:

Fifteen cards are laid out as shown in the left figure of the lower drawing. Any audience member selects a card mentally and announces the column in which it lies.

The cards are gathered up and dealt again. The same card is noted by the audience member, and its column is announced. Again the cards are picked up, re-laid, and this time, when the column containing the chosen card is pointed out, the magician instantly detects the card.

50

The Secret:

1. Suppose the Jack of Spades is the card chosen mentally. Its column is pointed out in the first arrangement of the cards, as shown in the lower drawing.

2. In picking up the cards, the aforementioned column is laid between the other two. The deck is then turned face down, and three new columns are dealt crosswise in columns of three. They are made to overlap, however, so that they form the three vertical columns. The second layout shows how the cards may lie. The column containing the chosen card is pointed out, and again it is placed between the other two. The cards are turned face down, and the crosswise deal is repeated, bringing the three columns shown in the final layout at the right of the bottom drawing.

3. This time the chosen card (Jack of Spades) is said to lie in the middle of the column. The magician can pick it out instantly, for it will be the center card of the column that is indicated by the audience member.

FINAL LAYOUT

PICK
UP IN
CENTER

PICK
UP
FIRST

PICK
UP
LAST

PICK
UP
FIRST

PICK
UP
LAST

PICK
UP IN
CENTER

Three Columns

Jacks are Better

You Gotta Have a Gimmick
a deck of cards arranged as described

This is a very clever and mystifying trick. It requires a slight amount of skill— just enough to make it interesting, and it can be learned very easily.

How the Trick Appears:
The magician shows four Jacks in a fan. He calls them four burglars who decide to rob a house, which is represented by the deck. He has the burglars enter the deck at different spots—top, center and bottom—which represent the front door, side door and back door, respectively. Then he cuts the deck—a signal to the burglars—and when he spreads out the deck, the four Jacks are found all together in the center!

52

The Secret:

1. Besides the four Jacks, two Kings are used. They are hidden at the back of the fan, behind the Jack of Hearts. The position is clearly shown in Figure 1. This is the only part of the trick where skill is needed, and anyone can easily learn to hold the Kings squared up behind the Jack.

2. Lay the Jacks face down on top of the deck for a moment, then start to push them into different parts of the deck. Take the top two cards— supposedly Jacks—and push them to the center (Figure 2). But it is actually the two Kings that are going the center. The faces must not be shown.

3. Then you put a Jack on the bottom (Figure 3), carelessly showing its face as you do so. You turn up the top card and reveal that it's a Jack.

4. Then you cut the deck, and the four Jacks come together in the center, because there are really three on top, and one on the bottom.

TWO KINGS
CONCEALED HERE

FIG. 1

PUSH TWO TOP
CARDS IN THE CENTER

FIG. 2

PUT THE THIRD
CARD ON BOTTOM

FIG. 3

Jacks Are Better

The Row of Ten

You Gotta Have a Gimmick
Ace through Ten of Hearts

Here is an effective trick that is quick and surprising. It is one of the best of all experiments in impromptu magic, and will always prove interesting. Read the instructions carefully, and you will be able to work the trick the moment you pick up a deck of cards!

How the Trick Appears:
Ten cards are laid face down on the table. The magician turns his back and tells a member of the audience to move a number card from the left of the row to the right. When this has been done, the magician turns around, picks up a card and shows its face. The number of spots on the card tells the number of cards that were moved! The magician repeats the trick immediately.

The Secret:

1. The ten cards used run in order from Ace to Ten Spot, the Ace being at the left. The suits do not matter (Figure A).

2. No matter how many cards are moved, pick up only the card at the extreme right of the row; its spots will tell the number moved (Figure B).

3. You then put the card back and turn your back again, asking for more cards to be moved from left to right. This time, you add the number of the card you previously turned up to one, and count that many from the right, where you turn up a card (Figure C).

4. The first time you turned up a Three, so the second time you turn up the fourth card from the left (one plus three). To repeat the trick, you would have to add five more (as the drawing indicates five moved), making nine from the right. The numbers in the drawing are simply given as examples.

54

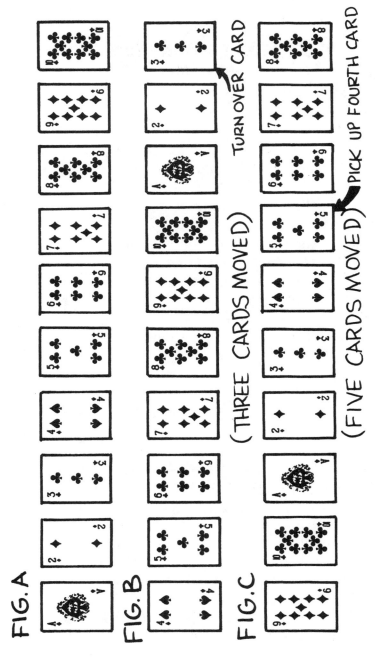

The Row of Ten

The Spelling Bee

You Gotta Have a Gimmick
13 cards of one suit

Thirteen cards are used in this trick. The cards are quickly arranged in advance; then the magician is ready to perform!

How the Trick Appears:

The magician takes a pile of thirteen cards in his hand. He puts the top card under the deck, saying, "A." He puts another card under, saying "C," and another under saying "E." He turns up the next card and it is an Ace!

Next he puts a card under and says "T" then another, saying "W" and another, saying "O." He turns up the next card and drops it on the table. It is the Two Spot! He continues to do this with the rest of the cards from Three to King.

56

The Secret:

1. This mystery depends on the arrangement of the cards, and careful dealing.

2. Everything is shown in the drawing on page 57, which gives the arrangement of cards (3S-8S-7S-AS-QS-6S-4S-2S-JS-KS-10S-9S-5S), the method of dealing, and the final result.

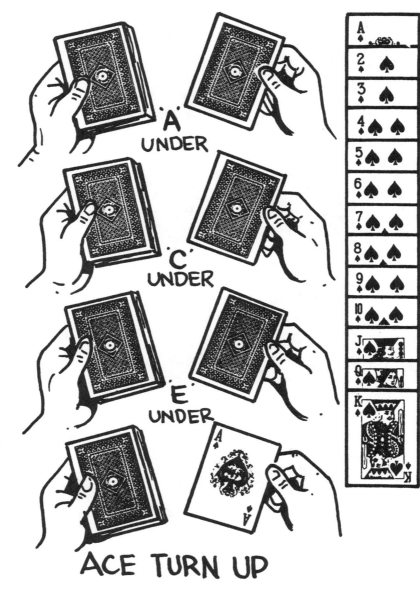

57

'A'
UNDER

'C'
UNDER

'E'
UNDER

ACE TURN UP

The Spelling Bee

The United Pairs

You Gotta Have a Gimmick
4 Kings and 4 Queens

This is really two tricks in one, so they are explained together.

How the Trick Appears:

The four Kings are laid in a pile, as are the four Queens. The two piles are placed together, turned face down, and cut several times. The magician puts them behind his back, and draws out each pair together—King and Queen of Spades and so on.

The Secret:

1. Cutting the deck causes no difficulty, provided each cut is a single one and is completed.

2. As soon as the cards are behind your back, separate the top four cards from the lower four. Then, bring out the top card from each pile. The cards will be the King and Queen of the same suit.

3. Refer to Figure A. Note that the four Kings and four Queens are in the same order of suits: Heart, Club, Diamond and Spade. This is essential.

How the Second Trick Appears:

The magician puts the united pairs together. The deck is cut several times. The cards go behind and he brings out the Kings in one hand and the Queens in the other!

The Secret:

1. Note Figure B. Make sure each King is below a Queen. Gather the cards, put them behind your back and separate the odd and even cards. One group will be Kings and the other Queens.

58

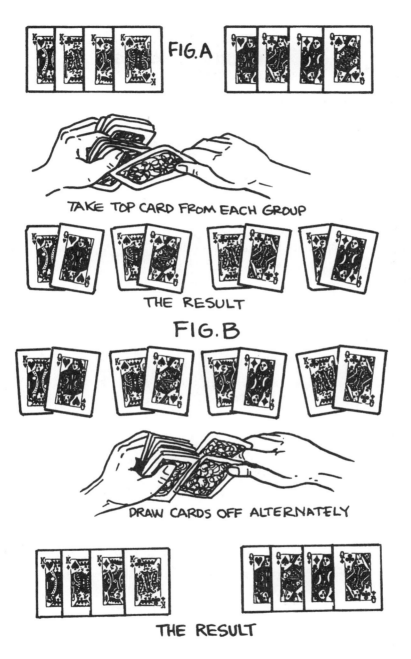

FIG. A

TAKE TOP CARD FROM EACH GROUP

THE RESULT

FIG. B

DRAW CARDS OFF ALTERNATELY

THE RESULT

The United Pairs

The Mental Divination

You Gotta Have a Gimmick
deck of cards

The entire deck of fifty-two cards is used in this trick, which depends upon an ingenious principle. If all of the cards are used, they can easily be laid out on a table.

How the Trick Appears:

The deck is laid out as illustrated. The order of the cards in each row may be varied, but the court cards should be at the left and the same cards always at the right of each row.

An audience member selects a card mentally. He tells the magician in which rows he sees a card of that number. If he should pick a Ten, he would say rows 3 and 4; a Queen, rows 2, 3, and 4; an Ace, row 1.

Then he looks at the court cards and tells the magician in which rows a card of the chosen suit appears, among the court cards.

Thus, if he selects a Seven of Diamonds, he says: "I see my number in row 4; my suit among the court cards in rows 1, 2, and 4." The magician instantly names the chosen card!

The Secret:

1. Assign the value of 1 to row 1, 2 to row 2, 3 to row 3, and 7 to row 4. The top row stands for Spades; the second for Clubs; the third for Diamonds; the fourth for Hearts. The card at the right of each row gives the key to that row. Consider the Jack as having a value of 11, Queen 12, King 13.

2. If an audience member says, "I see a card of my number in rows 1 and 3," you will know that it is a four spot, by adding 1 and 3. If he says he sees a card of his number in 1, 3, and 4, you know that it is a Jack by adding 1, 3, and 7, to total 11.

60

3. If the audience member says, "I see a card of my suit in rows 1, 2, and 3," you'll know the suit is Hearts—its omission means Hearts.

4. If he says, " I see a card of my suit in rows 1, 3, and 4," you name Clubs as the suit—because row 2 (omitted) stands for Clubs.

5. Remember that in telling where his suit lies, the audience member must look at the court cards only. That is why they are segregated. They may even be pushed a little to one side. Remember also that row 4 has a value of 7 in adding.

6. There are several things to learn in order to perform this trick quickly but, with a little practice, it can be performed without an instant's hesitation.

> *Many tricks in magic use mathematical principles. The illustration on the following page shows the layout of the pack of cards.*

61

62

The Mental Divination

Mystic Addition

You Gotta Have a Gimmick
deck of cards

This trick depends upon a simple system that makes it easy for the magician, but to the uninitiated, the method is undetectable. It is performed with a complete deck of cards.

How the Trick Appears:

A member of the audience takes the deck of cards and removes a card, noting the number of spots upon it. He lays it face down and deals enough cards to bring the total to twelve, each additional card counting as one. For example, the first card is a Five. The audience member must lay seven cards upon it, dealing the cards face down, and paying no attention to their faces.

He chooses another card from the deck, and proceeds the same way. An Ace has the value of one, but if a court card is chosen, it is counted as ten. He continues thus, selecting another card and dealing upon it, until the entire deck is exhausted. If the deal comes out uneven—that is, if there are not enough cards to bring the total of the last chosen card to twelve—the last chosen card and the extras are laid aside face down.

Figure 1 (see following page) illustrates a typical deal. There are two cards left over. Although all this takes place while the magician is not looking, when he turns around, he simply picks up the extra cards and immediately names the grand total of the bottom cards of the various piles. In this case, the total is 41 (see Figure 1). He does this despite the fact that the bottom cards are turned face down!

The Secret:

1. Count the number of piles (in this case seven), subtract four from that number (leaving three), then multiply that total by thirteen (making thirty-nine).

2. Add the number of extra cards (two) and you have the total!

63

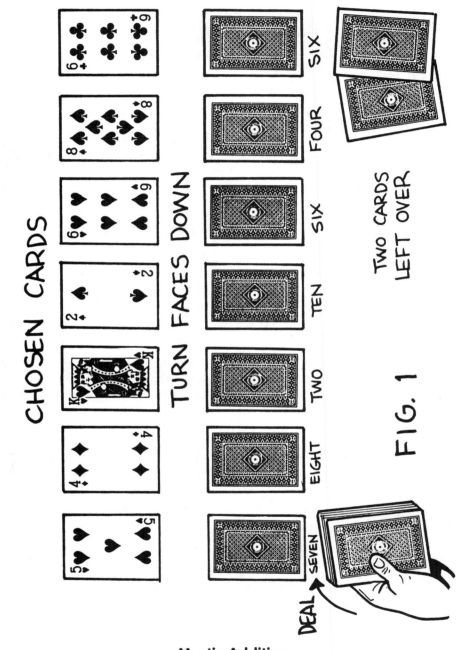

CHOSEN CARDS

TURN FACES DOWN

SIX FOUR SIX TEN TWO EIGHT SEVEN

DEAL

TWO CARDS LEFT OVER.

FIG. 1

Mystic Addition

Mental Detection

You Gotta Have a Gimmick
deck of cards

Here is a card trick that has all the elements of a real mystery. It rivals some of the best feats of sleight-of-hand, and it has been known to baffle experienced magicians. Yet, it can be performed without skill or practice!

How the Trick Appears:
The magician lets an audience member shuffle the deck. Then the audience member is told to look through the deck from the bottom, and to remember any card he sees—also its number from the bottom of the deck.

We will suppose that the Eight of Hearts is chosen, and that it is seven cards from the bottom.

The magician places the deck behind his back, and states that although he does not know the name of the card nor its number from the bottom, he will try to move it to any desired position in the deck. He asks that a number be named, larger than the original number.

Let us suppose that the number nineteen is chosen.

The magician puts the deck behind his back, and shifts the cards around a bit. He then states that he has placed the chosen card nineteen from the top—less the chosen number (seven), which he does not know!

He brings out the deck and gives it to the audience member, telling him to count from the top, starting with his chosen number (seven). The audience member counts "seven," "eight," "nine" and so on, laying a card aside on each number.

When the audience member reaches the number nineteen, he is told to turn the card face up, and it proves to be the chosen card! That is, the card is the Eight of Hearts.

65

The Secret:

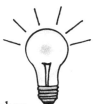

1. In Figure 1, the chosen card, the Eight of Hearts, is shown seven from the bottom. At this point, you do not know the card, nor do you know its position.

2. When you put the deck behind your back, ask for a larger number, stating that you will put the chosen card in a new position, although you don't know the chosen card nor its present position (See Figure 1-A)!

3. When nineteen is given, you quietly count the nineteen cards from the bottom and put them on top—but you do not change their order (See Figure 2 and Figure 3). This takes place behind your back and the audience does not know what is going on. The trick is then as good as done.

4. You then say that you have put the chosen card nineteen from the top—less the number (seven) that it was originally from the bottom. The audience member therefore starts his count with seven (Figure 4) and ends with nineteen, at which time he turns up the card and finds it to be the chosen Eight of Hearts (see Figure 5)!

You can perform this trick without knowing why it works, but the following explanation of the principle will enable the magician to understand it thoroughly.

If the audience members chose the bottom card, they would be taking a card from the bottom—namely the Five of Clubs (see Figure 1). Then, by shifting nineteen cards from bottom to top, the chosen Five of Clubs would naturally be five from the top. In this case, the count would begin with number one and would end with nineteen, the chosen card.

Suppose the fifth card from the bottom is chosen (King of Clubs). When the magician asks for a larger number, suppose he is given twelve. He then transfers twelve cards from bottom to top. The audience member will start the count with five, and the count will end at twelve, turning up the King of Clubs.

FIG. 1

FIG. 1-A
HOLD PACK
BEHIND BACK

FIG. 2
COUNT OFF 19 CARDS
FROM BOTTOM —

19 CARDS

AND — TRANSFER
THEM TO TOP.

FIG. 3

PACK

19 CARDS

FIG. 4
SPECTATOR
COUNTS "SEVEN" —

FIG. 5

— AND TURNS UP 19

67

Mental Detection

Mystical Divination

You Gotta Have a Gimmick

deck of cards

"Mental tricks" that appear to depend upon thought waves are always very effective. This trick seems to be one of genuine mind reading—if properly performed. And there is no reason that it should not be properly performed, for it is a trick that virtually works itself. The secret of this trick is so subtle that it has amazed even experienced magicians.

How the Trick Appears:

The magician deals sixteen cards into four piles of four cards each. Then he gives one pile to each of four audience members. Each person remembers a card in his pile.

The magician gathers up the cards and deals them into four piles. He takes up the first of these new piles, shows the faces of the cards, and asks if any of the audience members sees his mentally selected card in the pile. If a person says yes, the magician instantly picks out the card. He repeats this with the remaining piles until he has picked out every chosen card without failure. He does not even have to look at the faces of the cards!

The Secret: Method 1

1. The four piles as first shown are displayed in Figure 1. Show pile A to the first person, B to the second, C to the third and D to the fourth. When the piles are assembled, lay A face down and place B on top of it, followed by C and D.

2. Deal the cards in four piles (Figure 2). When you show one of the new piles, display it to each person, asking if his card is in view. If the audience member answers yes, you know it is the card designated by A in that group (as shown in Figure 3). If the second audience member sees his card, it will be card B, the third person C and the fourth person D. In other words, one

of each person's cards is in each group, and the magician knows exactly where it lies. So as soon as the audience member admits his chosen card is in view, you can identify it!

The Secret: Method 2

1. This dispenses with the deal in Figure 2. Give four cards to each of the four audience members, and tell each to select a card mentally.

2. Walk to D and take a card from him. Get a card from C, and lay it face down on the card you took from D. Then, retrieve a card from B, followed by A. Repeat this process until all the cards have been collected.

3. In this way, you automatically perform the deal. You only have to show the top four cards of the pile you have gathered, and they will be arranged just as shown in Figure 3.

The Secret: Method 3

1. Use two decks of cards, taking the same sixteen from each. Referring to Figure 1, put each group of cards in a separate envelope. Then take four sheets of cardboard; to each one attach one of the groups shown in Figure C.

2. Lay the cardboard sheets to one side and hand each of four audience members an envelope. Then show each cardboard sheet to each man in turn, and whenever a member of the audience announces that his chosen card is there, you can instantly pick it out.

This trick has been described with four groups of four cards each, but it can be done with five groups of five cards each, six groups of six cards each, or seven groups of seven cards each. If as many as six or seven people are present, the effect is better.

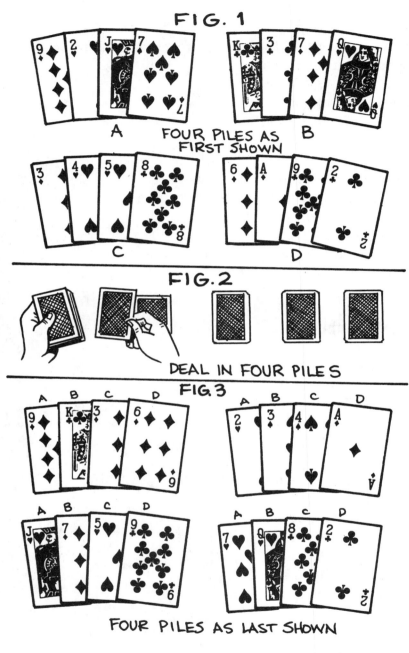

FIG. 1

A

FOUR PILES AS FIRST SHOWN

B

C

D

FIG. 2

DEAL IN FOUR PILES

FIG. 3

FOUR PILES AS LAST SHOWN

Mystical Divination

The Magic Pile

You Gotta Have a Gimmick
deck of cards

"The Magic Pile" is a trick which is very effective in operation as it is a mathematical trick that depends upon algebra and not upon simple arithmetic. The application of the principle is so unusual that no one ever detects it.

How the Trick Appears:
The magician turns his back, and tells an audience member to deal three piles of cards, with at least four cards in each pile. Each pile must have the same number of cards, but the magician does not know the number.

"The middle pile," says the magician, "has a peculiar attraction about it that enables me to picture how it can be manipulated to bring any number of cards in it between one and twelve. How many cards would you like it to have?" (We will suppose the answer is "five.")

"Very well," says the magician, "deal three cards from the right pile into the center." (This is operation A in the illustration.)

The audience member is then instructed to count the number of cards remaining in the pile on the left. Assuming that there were eleven cards in each pile at the beginning, he will find eight cards in the left pile (Operation B).

The magician tells him to pick up the center pile and to count the number of cards from the center pile that he found in the left pile, and to place them in the pile on the right (Operation C). In this case, there are eight cards in the left, so the audience member counts that many from the center pile and puts them in the right pile.

"Now," says the magician, "take the center pile and from it put two cards in the left pile and two cards in the right pile (Operation D).

As soon as the audience member has followed these instructions the magician tells him that he has the desired five cards in the pile!

Bear in mind that the magician has no idea how many cards are in each pile at the outset. Everything is done while his back is turned. The use of eleven cards in each pile (upper left drawing) is merely for purpose of example. There could be ten or fifteen cards in each pile, the only provision being that each pile must hold the same number.

The Secret:

1. Operations A, B, and C are always the same. It makes no difference how many cards are used; you do not have to know. For, at the end of operation C, there will always be exactly nine cards in the center pile.

2. Because the card quantity may vary, operation D must be varied to bring the middle pile to the desired number. The use of a few meaningless operations at this point will be helpful, such as the transfer of two cards from the left pile to the right.

3. Suppose the audience member wants two cards in the center pile at the finish. You can have him add one card to the center pile from the left pile (making ten in the center) and then order four cards dealt to the left and four to the right from the center pile, leaving two in the center pile. If twelve is desired at the center, three cards can be added to the center pile.

4. Always remember to do operations A, B and C the same each time the trick is performed. Then there will be nine cards in the center pile, and by one operation D, or by a series of operations, you can get the middle pile to the desired number in any way that suits your fancy.

Tricks sometimes do not work. Don't worry, it happens to the best magicians. Just go right into your next effect like nothing happened.

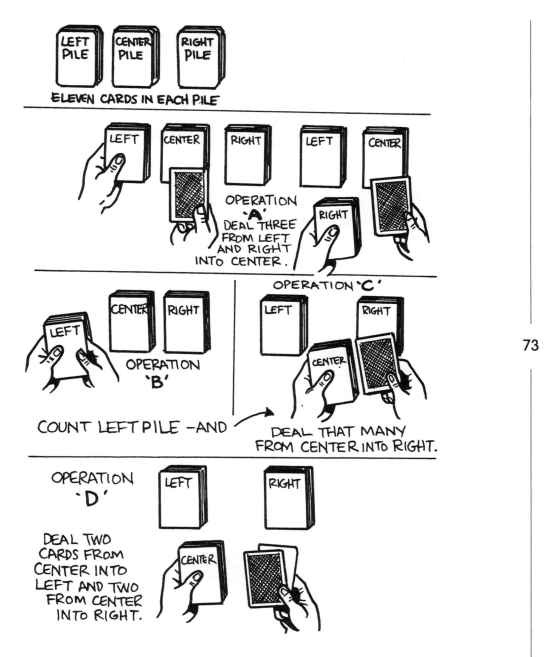

ELEVEN CARDS IN EACH PILE

OPERATION 'A'
DEAL THREE FROM LEFT AND RIGHT INTO CENTER.

OPERATION 'B'

OPERATION 'C'

COUNT LEFT PILE —AND DEAL THAT MANY FROM CENTER INTO RIGHT.

OPERATION 'D'

DEAL TWO CARDS FROM CENTER INTO LEFT AND TWO FROM CENTER INTO RIGHT.

The Magic Pile

73

You Gotta Have a Gimmick
deck of 52 cards

It is not a good idea to repeat a trick, as its secret might be discovered. It will be observed that many of the tricks in this section bear marked points of similarity, but the principles, or methods, are different.

This enables the magician to comply with the request of "do it again" by presenting a trick which is similar, but not identical to the one he has just done. This will bewilder the audience more than ever. This trick is also a partner for "Mystic Addition." Although it is different, it is similar enough that the two can be effectively worked together.

74

How the Trick Appears:

The deals are made similarly to the "Mystic Addition," but in this case the Ace counts as eleven, while the court cards are still ten. In the magician's absence, three cards are chosen and laid face down on the table. Enough cards are added to make the total of each pile fifteen, and the balance of the deck is laid aside.

The magician, upon his return, picks up the leftover cards and names the total of the three chosen cards.

The Secret:

1. Figure A shows a typical choice of three cards and the number of cards dealt in each pile. Twenty-eight cards are left over.

2. You simply count the leftover cards, and subtract four from the total. In this case the three bottom cards total 24 (King counting as ten). There are 28 leftover cards, so a subtraction of four gives the total. It works with any cards.

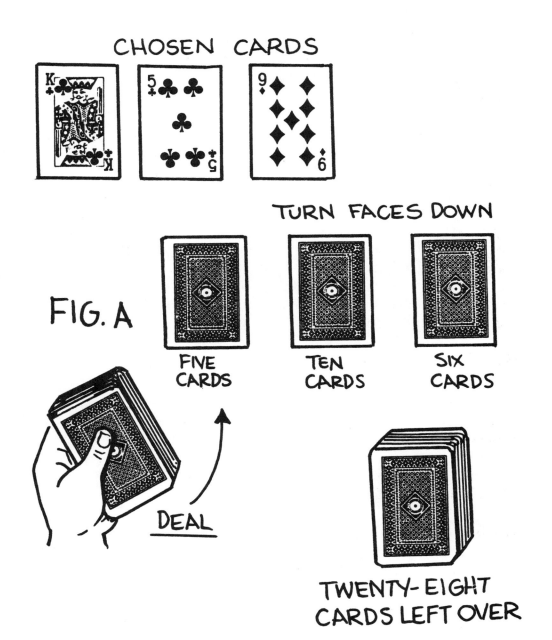

CHOSEN CARDS

TURN FACES DOWN

FIG. A

FIVE
CARDS

TEN
CARDS

SIX
CARDS

DEAL

TWENTY-EIGHT
CARDS LEFT OVER

75

Pile it On

Part IV

Tricks With Coins
Featuring Popular Coin Tricks

Cash in on doing coin tricks; they are second only to card tricks in popularity! The basic items needed for these tricks naturally consist of coins ranging in size from a penny to a half-dollar, according to those best suited to each individual trick. Along with these coins, some other common materials are essential— matchboxes, a hat, a glass and a plate, and a length of string as specified in the instructions. Included in this section are tricks involving Chinese coins because they have holes in the center. Coins of various other countries that have holes can be used instead, as well as metal washers that are obtainable at any hardware store. They all serve the same purpose. Coins, like cards, are ideal for beginners as a test of the following tricks will prove.

Coin Balanced on Handkerchief

You Gotta Have a Gimmick
a handkerchief and a half-dollar or quarter

How the Trick Appears:
The magician places a coin in the center of a handkerchief. The cloth is folded in half and the coin balances itself on the folded edge.

The Secret:

1. First fold the handkerchief so that it is one quarter its size. This is done by folding it twice.

2. Lay the coin in the center of the handkerchief and take hold of the opposite corners exactly as shown in Figure 1.

3. Draw on the handkerchief corners and you will find a groove or channel forms across the cloth; the coin will balance on the edge in that channel (see Figure 2). It is best to use a large coin—a fifty cent piece if possible—as the coin will show up better according to its size.

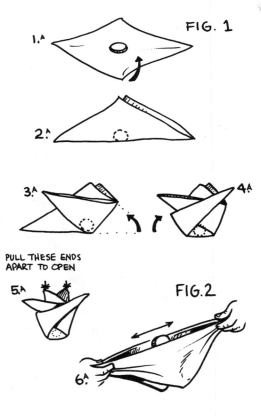

Coin Balanced on Handkerchief

Coin and Matchbox

You Gotta Have a Gimmick
an empty box of matches, a penny, and a piece of felt

How the Trick Appears:
The magician has an empty matchbox, which is opened so the audience can see inside. When the box is closed and opened again, a penny appears inside!

The Secret:
1. Arrange this trick beforehand. Open the matchbox drawer halfway, and wedge the coin between the cover and the end of the drawer. The drawer is half open when you do this (see Figure 1).

2. Show the matchbox as if it is empty. When you close it, the coin will drop into the drawer and appear there when the box is reopened. If a piece of cotton or felt is placed in the bottom of the matchbox, it will stop the coin from "talking" or making a noise as it hits the bottom of the matchbox.

79

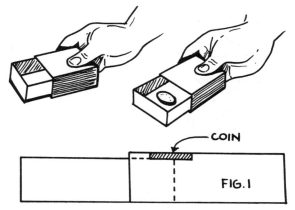

COIN AND MATCH BOX

Coin and Matchbox

Two Balanced Coins

You Gotta Have a Gimmick
a wooden match and two small coins

How the Trick Appears:
Here is a very clever trick involving two coins of the same size—pennies for example. The coins are laid on the left hand, and then the right hand lifts them between the thumb and forefinger, the coins being side by side. To everyone's surprise, the coins are balanced between thumb and forefinger!

The Secret:
1. The illustrations show how the coins appear in the front, as the audience sees them, and how they appear in the back, where nobody sees them.

2. Beneath the coins you have a piece of a match or toothpick, just the length of the combined width of the coins.

3. When you hold the coins together, the hidden piece of wood supports them, and enables you to hold them together in this mysterious manner.

Watch your angles on this one. The trick is most effective when viewed head-on.

80

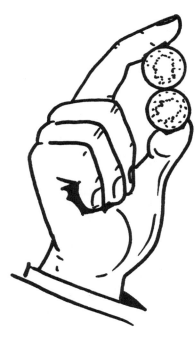 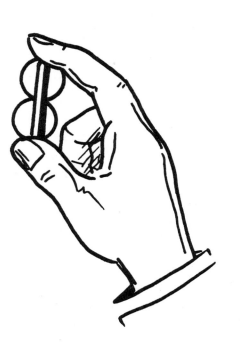

Two Balanced Coins

Finding the Chosen Coin

You Gotta Have a Gimmick
8 pennies—all with different dates—and a paper bag

How the Trick Appears:
The magician needs about eight or nine pennies to perform the trick; all of the coins should bear different dates. The magician asks an audience member to drop the pennies in the bag and then to take one out at random.

The selected coin is passed around so that all but the magician may take note of the date on the coin before it is

dropped back in the bag with the others. Reaching in the bag the magician immediately retrieves the chosen coin—even though he never saw the date on it.

The Secret:

1. In passing the coin from hand to hand, the coin becomes warm.

2. When you reach in the hat, feel the coins until you find the warm one!

82

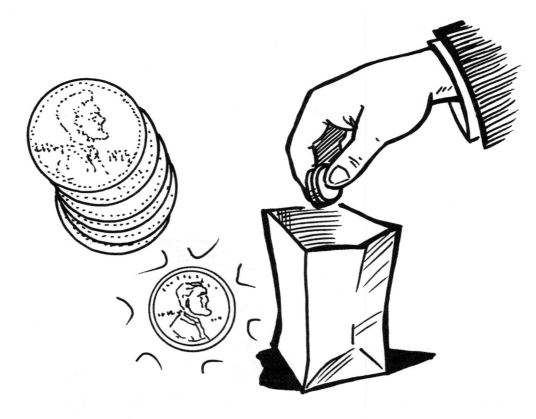

Finding the Chosen Coin

The Spinning Coin

You Gotta Have a Gimmick
a nicked half-dollar or quarter

How the Trick Appears:
The magician spins a coin on the table. Although his back is turned he can immediately tell whether the coin lies heads or tails the instant it stops spinning.

The Secret:
1. To accomplish this, take a coin and make a nick in the edge on the heads side.

2. Let an audience member spin the coin, and listen closely as it stops. If it stops slowly, you will know the coin lies heads up. If it comes to a sudden stop, you will know that the coin lies tails up. Use a penknife to make the nick in the coin.

83

The Spinning Coin

Coin Through the Sleeve

You Gotta Have a Gimmick
any small coin

How the Trick Appears:
The magician borrows a penny and drops it into his left coat-sleeve. Everyone in the audience is astonished when he proceeds to draw the coin right through the sleeve, near the elbow!

The Secret:
1. The drawing shows how the trick appears. Below you see the secret. A duplicate coin is set between the buttons of the coat-sleeve. It is out of sight.

2. The right fingers draw this coin down toward the elbow. As the coin is hidden from view, it appears that the original coin is drawn through the sleeve of the coat.

84

Palming is the term used when an object is secretly being held by a magician!

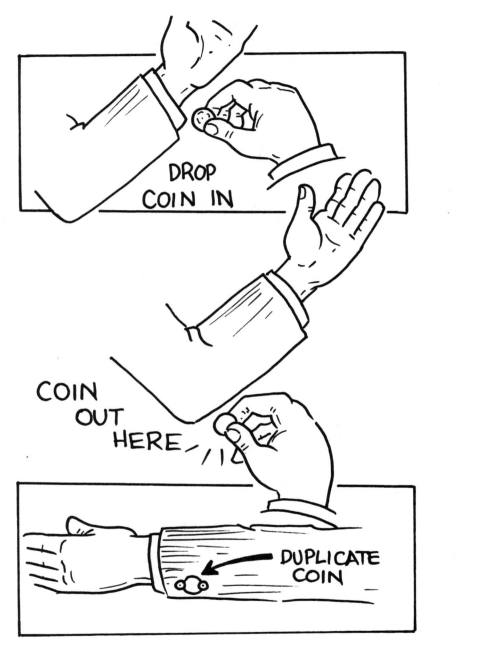

DROP
COIN IN

COIN
OUT
HERE

DUPLICATE
COIN

Coin Through the Sleeve

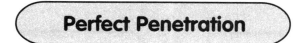

Perfect Penetration

You Gotta Have a Gimmick
2 tumblers, several small coins, a playing card

How the Trick Appears:
Two plastic tumblers separated by a playing card are placed on the table. Next the magician takes several coins and holds them above the tumbler. Everyone in the audience can see that both tumblers are empty. When he drops the coins, one of them penetrates the top tumbler and the card, and arrives in the bottom tumbler! The tumblers, the card, and the coins can all be examined.

The Secret:

86

1. To do this you must first place a coin on the edge of the tumbler, then set the card upon it. Push the coin slightly inward so that only the weight of the card holds it in place.

2. When you drop the coins with the right hand, lift the tumbler very slightly to the left. This releases the coin and it falls into the tumbler. The coin is slipped onto the edge of the tumbler under the cover of the playing card.

Sometimes someone will figure out how one of your tricks is done and will yell the secret to the audience. If this happens, remember that all those watching you are there because they wanted to see your magic. Don't let one person spoil the fun for everyone.

DROP
COINS IN
PLASTIC
TUMBLER

ONE
FALLS
THROUGH

PLASTIC
TUMBLER

TILT
CARD UP

COIN

Perfect Penetration

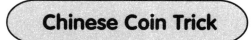

Chinese Coin Trick

You Gotta Have a Gimmick

a piece of rope or string (about 2 feet long) and
2 identical washers, rings or Chinese coins

How the Trick Appears:

A Chinese coin is threaded on a string. Audience members hold the ends of the string. A handkerchief is thrown over the coin. The magician reaches beneath for a moment. He takes away the handkerchief and the coin is seen tied to the center of the string. In open view, the magician pulls the coin loose from the knot and takes it off the center of the string!

The Secret:

1. You must have a duplicate coin concealed beneath the handkerchief.

2. Put your hand under the cloth, holding the duplicate in your hand. As your actions are concealed, attach the duplicate to the center of the string by looping it as shown in Figures 1, 2, and 3.

3. Hide the original coin in your left hand. With your right hand lift off the handkerchief, showing the duplicate, which the audience supposes to be the original.

4. Slide your hand along the string and temporarily take the end of the string from the person holding it. Immediately give the string to the audience member, but first remove the original coin in your left hand and pocket it with the handkerchief.

5. Seize the duplicate coin and mysteriously pull it from the string.

A

B

C

D

FIG. 1

FIG. 2

FIG. 3

Chinese Coin Trick

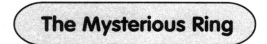
The Mysterious Ring

You Gotta Have a Gimmick

*a piece of string or rope (about 2 feet long) and
one ring or 2 identical bracelets*

This trick is very effective when combined with the "Chinese Coin Trick." After showing the coin trick, the magician is often asked to put the coin back on the string. He can do that in the method about to be described, which can be performed with the same coin or ring.

How the Trick Appears:

The magician's hands are tied together, with a loop of string between them in the manner shown in Figure 1. The knots are tied or sealed if desired.

The magician then takes a ring and turns his back for a moment. When he shows his hands, the ring is tied between them on the string (see Figure 6).

The Secret:

1. Take a loop of string and push it through the center of the ring (Figure 2).

2. Push the loop under the string in back of the wrist and bring the loop over the fingers again (see Figure 5). As a result, the ring will be tied on the string (Figure 6).

3. With a little practice these movements can be performed very rapidly. Another method requires a large ring the size of a bracelet. A duplicate ring is up the magician's sleeve. He turns his back, drops the original ring in his inside pocket and lets the duplicate slide from his sleeve, over his hand, and onto the string.

90

FIG. 1

FIG.2

FIG.3

FIG.4

FIG.5

FIG.6

The Mysterious Ring

The Mystic "Q"

You Gotta Have a Gimmick
12 coins

This trick is performed with a number of coins, checkers, cards, matches, or any other objects that may be desired.

How the Trick Appears:

The magician lays some coins so that they form a Q. A member of the audience is told to start at the tail of the Q and count up and to the left as far as he chooses. Then, starting with the coin he counted on, he counts back around in the same direction, counting the same number as he did before. Although this is all done while the magician's back is turned, when the magician faces back around, he is able to point to the exact coin the count ended on.

The Secret:

1. The audience member who does the counting will always finish on the same coin, no matter what the number is. If he counted from A to B and then counted backwards, he would end on A. In reference to the coins in the circle of the Q, the count must end on D, although the audience does not realize it.

2. Note the squares marked X in Figure 2. You count them before the trick and count that many coins to the right of them, in the circle, as indicated by the dark coins. In that way you determine D to be the finish coin.

3. If the audience member counted 11 coins, he would land on C (Figure 1), and in counting back would land on the inevitable D. Any number can be chosen; the result will always be the same.

4. In repeating, take away or add a few coins as indicated in Figure 3. This changes the position of coin D, and prevents detection.

FIG. 1

FIG. 2

FIG. 3

93

The Mystic "Q"

Part V

Look Into My Eyes
Tricks of Hypnotism

Here are some mysterious feats that will prove surprisingly simple. Yet, they will actually create awe in the minds of many people. While they are basically tricks and therefore fall in the category of magic, some of them are actually preliminary "tests" used by hypnotists to put their subjects in a mood for more elaborate experiments. As simple as these "tests" are, they should be presented in a mystic manner in order to impress the audience as well as the subject. By gazing steadily into the subject's eyes, making passes with the hands and speaking in a commanding voice, the beginner can often convince his audience they are witnessing genuine hypnotism, so when other subjects try the tests, they will respond in the same fashion. Actually, they won't be hypnotized at all, but if they think they are, the result is impressive.

The Strength Test

How the Trick Appears:
The hypnotist chooses an audience member whose strength is about equal to his own and tells him that he will produce a magnetic power that will be impossible for the audience member to overcome.

To demonstrate this he holds his arms at chest level before his body, extends the forefingers of both hands, and sets them tip to tip. The hypnotist holds them there for a few moments, to produce a "magnetic force."

This is a very convincing demonstration, for the hypnotist is using no grip at all; he is simply putting the tips of his fingers together whereas the subject is using every ounce of his strength. It is a feat that appears impossible.

The Secret:

1. It all depends upon the position of the hands. By pressing your fingertips firmly together at chest level you have a great advantage and the strength which you are exerting will be much more effective than his attempts to draw your hands apart.

2. By this method, a person who is comparatively weak can actually exert more force than someone of superior strength, and it appears as though the subject has lost his natural powers.

96

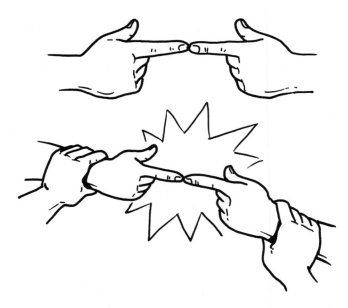

The Strength Test

Controlled Eyelids

How the Trick Appears:
This is a surprising stunt. The hypnotist tells an audience member to look straight ahead for a few moments, then to look upward without raising his head and to keep looking upward. He must raise his eyes to do this.

The hypnotist tells him to keep looking upward as much as possible and to close his eyelids. He must still look upward with his eyes closed, keeping his eyeballs in the same position.

The hypnotist then tells him to try to open his eyes. He follows this by saying in a firm voice that the person will be powerless to do so. When the subject has failed, as is observed by the quiver of his eyelids, the hypnotist tells him to relax—to lower his eyes as though looking toward his feet and to open his eyelids. He does this without trouble.

The Secret:
97

1. Here a very simple muscular principle is involved. It is impossible to open the eyelids when the eyes are looking upward. It is a very surprising trick to those who attempt it.

Immovable Fingers

How the Trick Appears:
The hypnotist tells a member of the audience to close his fists loosely and to set the knuckles of one hand against the knuckles of the other. He is then told to separate his hands and extend his ring fingers so that they touch tip to tip. The knuckles of the fingers on his opposite hands must be brought together so that the ring fingers are the only ones extended upward.

The hypnotist states that the subject will render the ex-

tended fingers powerless and that he will loose muscular control. The hypnotist states that the extended fingers cannot be moved apart of their own power without separating the knuckles of the hands.

To his surprise the subject finds he cannot move his fingertips apart; they seem to be held together by an uncontrollable force.

The Secret:

1. The third fingers do not possess the strength found in the other fingers. They simply cannot be separated when held in the manner described. You can take advantage of this little known fact to create a clever mystery.

98

Immovable Fingers

A Weak Knee

How the Trick Appears:

This is one of the most surprising of all hypnotic tricks. The hypnotist instructs an audience member to stand by the wall, with his right foot against the wall and his left foot five or six inches from his right.

The hypnotist makes a few passes toward the subject's left knee and then states that he has put the person in a hypnotic condition which deems his leg powerless. The hypnotist tells him to raise his left foot slowly without changing the position of his feet.

The subject tries to lift his leg but fails. Somehow all the strength has escaped his left knee. The sensation is positively uncanny.

Finally the hypnotist tells the subject to stop and to walk forward. At this point the subject regains the strength in his knee and the hypnotist's power is apparently broken.

99

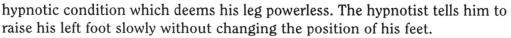

The Secret:

1. This is a very effective stunt and the best part is that you can try it for yourself to see how well it works.

2. The subject should not lean against the wall; he should merely place his right foot against it so the position is a comfortable one.

3. Any attempt to raise the left foot slowly means that the weight must be shifted to the right foot.

4. As the subject unconsciously attempts to shift his weight his right shoulder comes in contact with the wall and he can go no further; hence, he cannot put his weight on his right foot. He thinks he has done so, but the left leg still supports some of his weight and he cannot raise the left foot on that account.

5. The sensation of helplessness appears to be in the left knee and is very mysterious. Not one person in a thousand will realize where the trouble lies, for the trick is artfully simple.

100

A Weak Knee

The Electric Wave

How the Trick Appears:

The hypnotist holds his forefingers before the subject's eyes and
tells him to stare fixedly at the fingertips. The subject is then told
to close his eyes so that the hypnotist may place his forefingers
on top of his eyelids.

Speaking slowly, the hypnotist says, "You will now ex-
perience a strange sensation—an electric wave passing
through your hair."

The hypnotist's fingertips press on the subject's eyelids and the subject
feels a tingling that passes over the top of his head. When the command is
given for him to open his eyes, the fingertips are removed and the subject
finds himself once again staring at the hypnotist's fingertips.

The Secret:

1. When the audience member shuts his eyelids, you should
 extend the first two fingers of your right hand and touch the
 person's eyes. Since the subject has been looking at the tips of
 your forefingers, he naturally supposes that both of your hands are
 occupied.

2. At this point you pass your free hand lightly over the subject's hair, at the
 same time pressing with your fingers so that the subject cannot open his
 eyes. This is done carefully and the subject does not realize that a hand is
 touching him; it seems as though some electric force has moved his hair.

3. You then bring your free hand back to its original position and when the
 subject feels that the pressure has been removed, he opens his eyes to find
 himself looking at both of your forefingers just as in the beginning.

Done neatly, this trick has a surprising effect and the subject will look around for some apparatus that might have caused the effect. This is a one-man trick. When performed before several persons, it can only be done as comedy, as the audience will see the method and enjoy a laugh at the surprise of the subject. This trick has also been shown as a spiritualistic demonstration, the inference being that the touch on the head is due to "spirits."

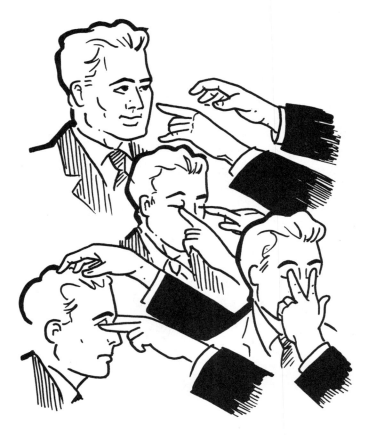

The Electric Wave

Magnetized Hand

How the Trick Appears:

A member of the audience holds out his hand and the hypnotist rubs the palm of his hand for a few moments. The magician then raises his hand and snaps his fingers. As if in answer to the command, the subject's hand moves upward.

The Secret:

1. When you suddenly take your hand away and snap your fingers, the person's hand will naturally move upward as though some magnetic force drew it in that direction.

103

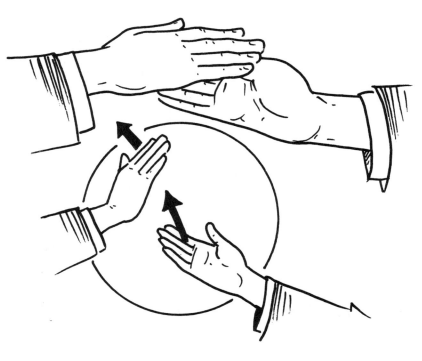

Magnetized Hand

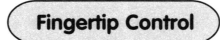

How the Trick Appears:

In this experiment an audience member is seated in a chair. He lies backward, folds his arms and extends his feet. The hypnotist tells him to retain this position for a few moments.

The hypnotist then announces that he will keep his subject from rising by simply placing his fingertip upon his forehead.

The magician presses the subject's forehead in the matter stated and says, "You cannot rise. You are powerless. Try to rise."

The subject strains and uses every effort but finds that he is helpless. Finally the hypnotist remarks, "You are now able to rise," and removes his finger. The subject then gets up without any difficulty.

The Secret:

1. To perform this trick successfully you must first experiment with a friend and learn the exact position recited. The subject must have his feet well extended and his head well back so that he is reclining. The object is to have him in a position in which he must raise his head in order to get up from the chair. You must insist that he keep his feet extended and his body somewhat rigid in order for your "hypnotic force" to be exerted throughout his body.

2. The pressure of your finger is sufficient enough to hold him down. Your finger must be firm and well centered against the middle of the forehead to prevent slipping. Do not prolong the trick more than several seconds.

This is a very effective hypnotic trick and is by no means difficult. It should, however, be practiced in order for it to be performed with certainty.

104

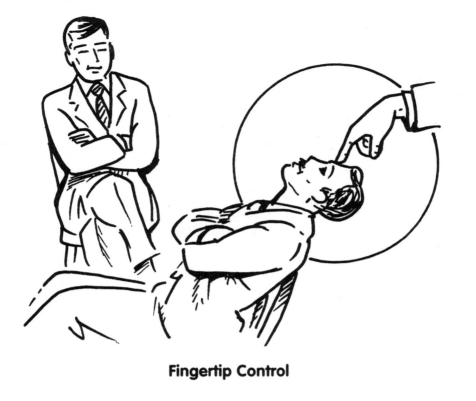

Fingertip Control

105

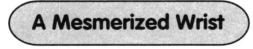

How the Trick Appears:

The hypnotist instructs a member of the audience to clinch his fist, with his thumb inside, then to double up his arm and press his fist firmly beneath his shoulder, under the armpit.

The hypnotist then requests that the subject slide his thumb from his fist. This is accomplished without difficulty.

"That was easy," the hypnotist says, "but I shall now make the same operation very difficult. Hold your fist where it is and try to put your thumb back in your fist. You cannot do it!"

The Secret:

1. When the person tries to put his thumb back in his fist he receives a wrench at the wrist. It is a very surprising muscular sensation and it gives the impression that some force has gripped the wrist and rendered it powerless.

2. The same trick will work with some persons if the fist is placed firmly on top of the shoulder, near the neck. This is an easier position to attain, but it is not a sure-fire.

3. In either case, the fist must be pressed firmly in position. Relaxation of the hand will interfere with the trick so make sure that the subject follows your instructions to the letter.

106

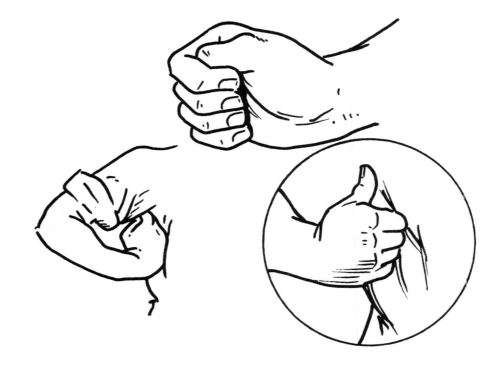

A Mesmerized Wrist

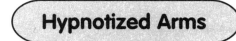

Hypnotized Arms

How the Trick Appears:

The hypnotist instructs his subject to stand in a doorway with the backs of his hands against the sides of the doorway. The subject is told to push with all his strength, as if he is keeping the sides of the doorway apart.

The hypnotist speaks slowly and informs the subject, "You are entering a mental condition that will enable me to control your response to any movements I make."

The hypnotist finally tells his subject to come forward, stating that the subject will follow his lead. As the subject steps from the door, the hypnotist raises his hands from his sides. Much to the surprise of the subject—and those who witness the trick—the subject's arms rise in time with those of the hypnotist until they nearly reach his shoulders.

The Secret:

1. The secret behind this trick is pressure. The subject's arms are straining upward when they press against the sides of the doorway. Walking forward relieves the restraining and the arms, now free, will rise of their own accord. In order to make this trick work, give your little talk while the person is standing in the doorway.

While this is a comparatively simple trick, it may be shown effectively and works very well. The performer apparently causes a person's arms to rise by auto-suggestion and, if enough emphasis is laid upon that argument, the trick will prove very perplexing!

107

108

Hypnotized Arms

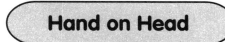

Hand on Head

How the Trick Appears:
This is a simple and surprising experiment. The hypnotist places his hand on the crown of his head and asks an audience member to move it from its position. Here, again, the strength of the subject seems to have vanished. He can pull, he can push, he can try to lift, but he will be unable to move the hypnotist's hand.

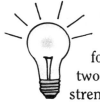

The Secret:
1. You do not have to exert a great deal of strength or pressure for this trick. A very effective way to perform this trick is to utilize two audience members. Tell one that you will give him superior strength and the other that he will be weakened.

2. Let the first subject place his hand on his head, pressing as little as necessary. Tell the second person to use every effort to draw away the first person's hand by tugging at the wrist. Both will be surprised; the first because he can resist with so little effort, and the second because he utilizes all his strength to no avail.

109

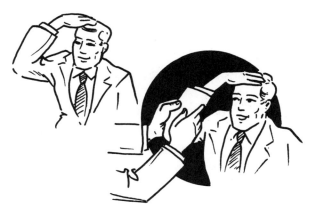

Hand on Head

Cold Air

How the Trick Appears:

The hypnotist tells his subject to hold one hand out-stretched, with the thumb pointing upward. He rubs the subject's hand and then holds his own hand so that the fingertips are close to his subject's palms.

The hypnotist says that he will cause a cold vapor to come from his fingertips, and that the subject will feel his palm grow cold. This does not happen immediately, so the hypnotist raises his hand for a moment and again places it near the subject's hand.

The hypnotist repeats this operation and this time the subject feels a coldness creep along the palm of his hand. This is extremely surprising and the subject wonders whether or not he is a victim of imagination!

110

The Secret:

1. You do not actually make the subject believe that his hand is cold; you physically produce a blast of cold air without the subject realizing it.

2. When he raises his hands you follow by swinging your hand toward his palm. Your fingers stop near the subject's palm and remain there. The motion of the hand creates a breeze that sweeps around the fingertips and makes the person's palm feel cold.

3. The purpose of rubbing the palm before the trick is to make it warm and therefore more susceptible to the cold. It is not necessary to sweep the hand rapidly through the air; an easy motion is sufficient. You can practice the trick by trying it with your own hands.

Cold Air

Hands Together

How the Trick Appears:

This is a trick with a double effect. With it, the hypnotist demonstrates how to make a person's strength virtually nil.

The hypnotist places his fists together and invites an audience member to draw them apart. He pulls on the hypnotist's arms, but cannot draw the hypnotist's hands apart.

The hypnotist then tells his subject to hold his fists together, so that the hypnotist may demonstrate to the subject that he has rendered him helpless. To do this, the hypnotist, using only his forefingers, pushes his subject's hands apart with ease.

The Secret:

1. Although this is a very convincing exhibition, strength has nothing to do with it. When you place your fists together—knuckles against knuckles—and extend your elbows, you have the other person at a disadvantage because he cannot exert his pulling strength sufficiently to draw your hands apart.

2. When the subject places his fists together, you do not attempt to draw them apart. Instead, extend your forefinger and hold one of your hands above one of his fists and your other hand below his other fist.

3. Having done this, strike downward with your upper hand and upward with your lower hand.

4. This action, performed sharply, will knock his fists apart so quickly that he will be completely surprised.

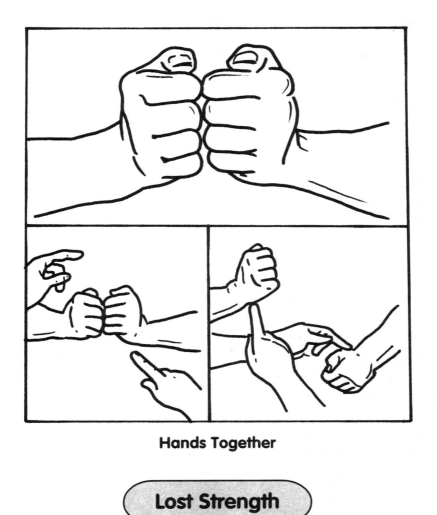

Hands Together

Lost Strength

How the Trick Appears:

The hypnotist states that he can press a certain nerve that will take away the strength of a man much larger than himself. The hypnotist touches the chin of a larger person, finds the particular spot he desires and presses there. At this point, he tells the subject to try to lift him. The person will grip the hypnotist under his arms and will use every effort to raise him from the floor, but without result.

The Secret:

1. The "nerve" in the chin is merely a clever pretext that enables you to accomplish the trick. In order to lift, the larger person must bend forward. He is prevented from doing this by you as you press his head backward by constantly holding your forefinger against his chin. Because of this, the subject is never in a position to exert proper strength; he is off balance and his power is deflected.

2. You must acsribe much importance to your search for the proper spot on the person's chin because this detracts attention from the actual method. Too much pressure should be avoided; you simply need too see to it that the subject's head moves back when he tries to lift you. In this manner, a person of lightweight can overcome the lifting efforts of a stronger man.

Lost Strength

Stopping the Pulse

How the Trick Appears:

This is an experiment which demonstrates auto-hypnotism, performed by those who have convinced many persons they are capable of hypnotizing themselves. Many believe this trick is supernatural. The hypnotist holds his arm and lets an audience member feel his pulse. Gradually the pulse beat lessens; it seems to die away and to disappear almost entirely. It creates the idea that the hypnotist controls his pulse with his mind.

The Secret:

1. A handkerchief tied into a hard knot is placed under your arm. The handkerchief is small so it remains hidden as you firmly press against it. The pressure reacts upon your pulse beat.

115

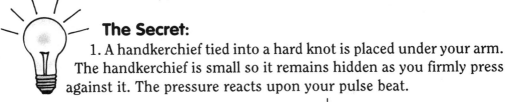

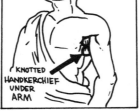

KNOTTED HANDKERCHIEF UNDER ARM

Stopping the Pulse

In concluding these hypnotic tricks, remember that they should be presented as entertainment; any talk of hypnotism is to be used only to add drama to your performance. Any tricks of pretended hypnotism that might be dangerous or objectionable have not been described. There are many so-called "tests" which are interesting and mystifying yet which should not be attempted by the layperson. Those that I have explained are all entertaining and none of them involve chances of injury to either the hypnotist or participating audience members.

Part VI

Round the Table Tricks
Perform Magic Around the Table

Performing magic at a dinner table, a card table, or in fact at any table, is ideal for the beginner. It gives his work an impromptu touch that convinces people his tricks are really clever—for anyone who can do magic should be able to produce his mysteries anywhere at any time. And what place could be more appropriate than in the middle of a family gathering? Add to that the fact that common articles can be used and even borrowed from members of the audience, and the beginner's fame is sure to increase by leaps and bounds. Instead of performing all these tricks at a table, some can be shown by moving slightly away from the audience. Also, many of the card and coin tricks described in previous sections are suitable for tablework.

Under the Rising Matchbox

You Gotta Have a Gimmick
a small empty matchbox

How the Trick Appears:
In performing this trick, an empty matchbox is best. It is placed on the left hand, flat with the label of the box facing downward, as illustrated in Figure 1.

The box then rises mysteriously to an upright position, apparently moving entirely of its own accord.

The Secret:

1. When you put the box on your hand, push the drawer out slightly and catch a bit of flesh between the drawer and the box.

2. Close the box, tilt your fingers forward and the box will rise!

Under Balanced Matchboxes

You Gotta Have a Gimmick
six small empty matchboxes

118

How the Trick Appears:

On the left you see the mystic balanced matchboxes—a whole stack of half a dozen boxes. Figure 4 illustrates the way the trick appears. Despite the fact that there are so many boxes, they balance there and do not fall. Everyone thinks that the magician is a clever juggler when he performs this trick.

The Secret:

1. As a matter of fact, there is nothing difficult about it. Figure 5, on the right, shows how to do it. The bottom box has no drawer. Push the drawer downward so that it locks into the box beneath.

2. Thus each matchbox will support the one above it, and you can handle the boxes in every careless fashion without worry of the matchboxes falling.

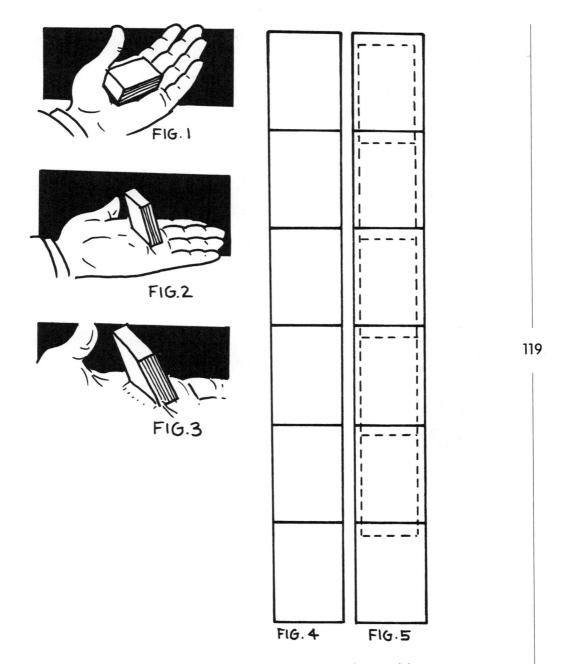

FIG. 1

FIG. 2

FIG. 3

FIG. 4

FIG. 5

119

Under the Rising Matchbox & Under Balanced Matchboxes

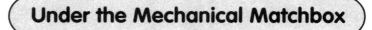

Under the Mechanical Matchbox

You Gotta Have a Gimmick
a small thin rubber band and a matchbox

How the Trick Appears:
This is the matchbox that closes itself. First the hypnotist shows it open, as in Figure 6. Then he says, "Presto," and the matchbox shuts itself! This is shown in Figure 7.

The Secret:
1. Slip a rubber band around the sides and ends of the box (Figure 8). Open the box and press the inner end firmly (Figure 9) to keep the box from closing.

2. Say "Presto," release pressure, and the box will close. Place a couple of wooden matches inside the match box for misdirection.

120

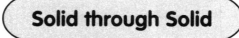

Solid through Solid

You Gotta Have a Gimmick
a two-inch safety pin, a match, and a toothpick or piece of wood that has a hole drilled in its center

How the Trick Appears:
The magician shows the pin and match (Figure A). He then snaps the pin shut and presses the match so it comes against the bar of the pin (Figure B). The magician gives the match a snap, or a hard push with his finger, and the match goes right through the bar of the pin shown in Figure C. The magician has pushed a solid object through another solid object and passes the pin around to any doubters!

The Secret:

1. Figures A, B, and C show what you do, but Figure D shows what really happens. When you snap the match, it flies back in the opposite direction, but goes so rapidly it appears to penetrate the bar of the pin. The eye cannot detect it.

2. A small piece of paper may be folded over the bar of the pin, which the match will also appear to penetrate. This trick is available at your favorite magic dealer and is included in many beginning magic sets.

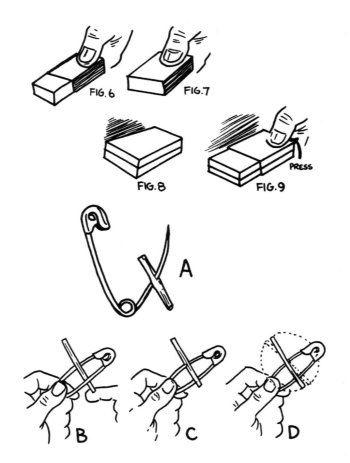

Under the Mechanical Matchbox & Solid through Solid

The Magic Square

You Gotta Have a Gimmick
a copy of the magic square and a toothpick, a match, a straw, a small pencil or any other object that will cover just five of the numbers

How the Trick Appears:
The magician instructs an audience member to drop a toothpick, a match, a straw, or a small pencil on the magic square so that it covers any five numbers. These numbers may run vertically, horizontally or diagonally.

The magician states he can tell the sum of the five numbers that are covered. Without looking, the magician announces the correct total, "sixty-five." When the five numbers are revealed, they are added up, proving the magician to be correct!

122

The Secret:
1. As long as five squares are covered—in any direction—the total will be 65. Because of this, once you have done this trick, do not repeat it to the same audience unless you want the secret found out.

2. If someone does ask you to repeat the trick, you can vary it by having either four or six numbers covered.

3. If four numbers are covered, you must deduct the square at the end of the match from 65.

4. If you cover six numbers, note the number of a square that is five squares from the squares at either end of the pencil, etc., and add it to 65.

This trick is even more effective if a written prediction is placed in a sealed envelope. Before beginning the trick, write the number 65 on a slip of paper. Place the paper in the envelope, seal it and hand it to a member of the audience for "safe-keeping."

24	11	3	20	7	24	11	3	20	7
5	17	9	21	13	5	17	9	21	13
6	23	15	2	10	6	23	15	2	19
12	4	16	8	25	12	4	16	8	25
18	10	22	14	1	18	10	22	14	1
24	11	3	20	7	24	11	3	20	7
5	17	9	21	13	5	17	9	21	13
6	23	15	2	19	6	23	15	2	19
12	4	16	8	25	12	4	16	8	25
18	10	22	14	1	18	10	22	14	1

The Magic Square

Orange Changes to Apple

You Gotta Have a Gimmick
a paper bag, an apple and an orange

How the Trick Appears:
The magician shows the audience an orange before placing it in a paper bag. When it is taken back out, it has turned into an apple!

The Secret:

1. Show the audience an empty paper bag. The orange you place in the bag is actually an apple covered in orange peels. When you remove the peels, the "orange" becomes an apple.

2. After you have peeled away the orange, crumple the bag up and toss it away as if there was nothing in it.

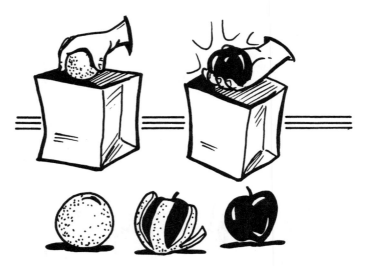

Orange Changes to Apple

Orange or Apple

You Gotta Have a Gimmick
an orange and an apple

How the Trick Appears:
The magician tells an audience member to hold an orange in one hand and an apple in the other. The magician then turns his back and tells the audience member to raise either the apple or the orange into the air, with his arm straight above his head, and hold it there. The magician then tells him to lower his arm. When the magician turns around, he is able to tell which fruit the person raised—the apple or the orange.

The Secret:
1. Your answer lies in the person's hands. The hand that was raised will be whiter than the other and the veins will be smaller due to the blood leaving it when raised.

125

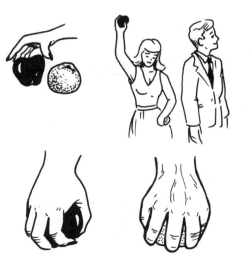

Orange or Apple

Two Handkerchiefs Tied

You Gotta Have a Gimmick
a small rubber band and two handkerchiefs, napkins or pieces of string

How the Trick Appears:
The magician begins this trick by holding two handkerchiefs side by side as shown in Figure 1.A.

 The magician then tosses them in the air. When they fall, they are tied together.

The Secret:
1. This trick is done very easily. Place a rubber band over the fingers and thumb of one of your hands.

2. Slip the rubber band over the corners of the handkerchiefs as you toss them and they will become "tied." Only you will know that the "knot" is not really a knot.

Thin rubber bands work best!

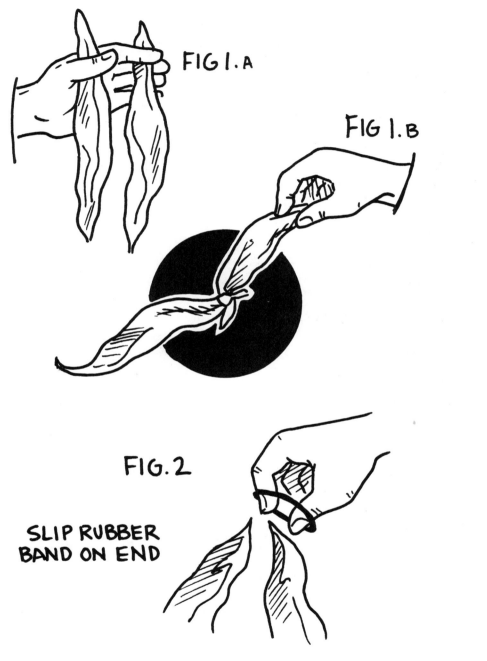

FIG 1.A

FIG 1.B

SLIP RUBBER
BAND ON END

FIG. 2

Two Handkerchiefs Tied

Balancing a Handkerchief

You Gotta Have a Gimmick
a white pipe cleaner and a handkerchief

How the Trick Appears:
The magician twists the opposite ends of the handkerchief and then balances the handkerchief upright on his forefinger (Figure 1).

The Secret:
1. The handkerchief you twist actually has a pipe cleaner inside it, which makes the handkerchief stand up straight.

2. At the end of the trick, you should crumple up the handkerchief so nobody knows how it was done.

128

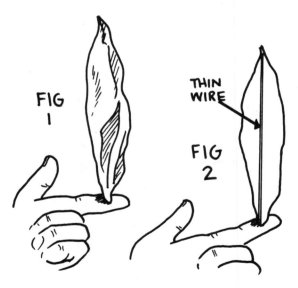

FIG 1

THIN WIRE

FIG 2

Balancing a Handkerchief

Shaking the Knot

You Gotta Have a Gimmick
a handkerchief prepared as described

How the Trick Appears:
The magician holds a handkerchief by one corner, gives two or three shakes, and a knot appears.

The Secret:
1. Start with a handkerchief that has one corner tied into a knot. Hold it as shown in Figure 1, with the knotted corner concealed in your hand.

2. Lift up the other corner with the same hand, give the handkerchief a quick shake and let the corner without the knot fall down. Do this a couple of times and appear disappointed when the knot does not appear. The last time you shake and drop a corner, let the one with the secret knot fall. Because of your feigned frustration, no one will catch on.

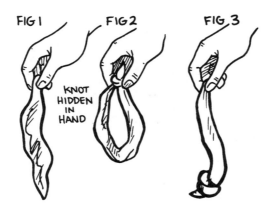

Shaking the Knot

Blowing through a Bottle

You Gotta Have a Gimmick
a candle and a 16 ounce soda bottle

How the Trick Appears:
The magician sets a lit candle behind a bottle. When he blows against the bottle, the candle goes out.

The Secret:
1. The air currents pass around the bottle, but it looks as though you have blown through it.

2. Be careful when using fire. Always have an adult's assistance.

130

Better you should perform one trick well than many tricks poorly.

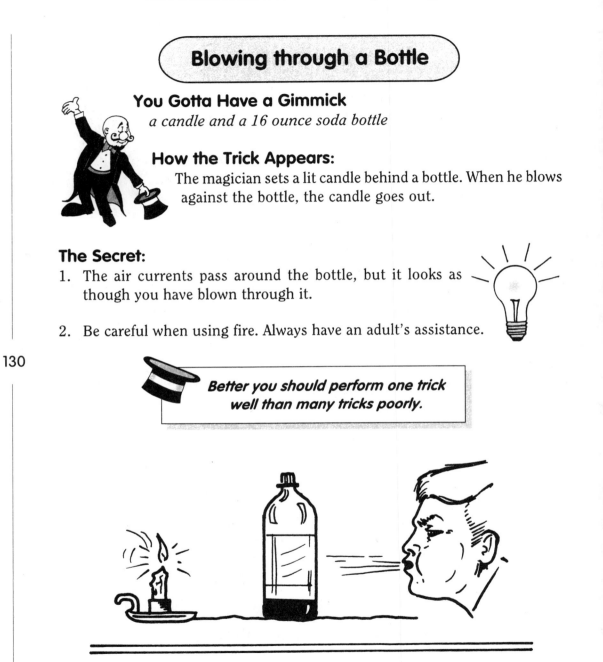

Blowing through a Bottle

Water That Is Not Wet

You Gotta Have a Gimmick

a bowl of water and talcum or stearate of zinc powder

How the Trick Appears:

The magician tells the audience that he is going to prove that water is not wet. He first shows a bowl of water, then dips his hand in it. When he removes his hand from the bowl, it is as dry as when it went in; there is not a drop of water on his hand!

The Secret:

1. Before you do this trick, rub your hands with powder. Dip your hand in the water. When you pull it out, it will be dry.

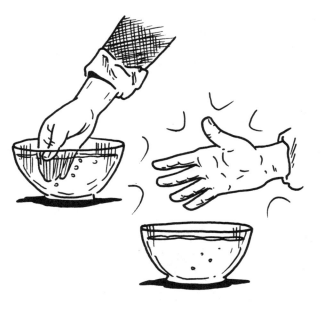

Water That Is Not Wet

Part VII

All Tied Up
Tricks With Strings

Thanks for stringing along with me. When you finish this chapter, your friends will say that you are knot a bad magician. All that is needed for these mysteries are a few lengths of string or light rope, plus some rings or metal washers. In most cases, knots are involved and the way they appear or disappear can become positively uncanny. Here, again, the methods are basically simple. In fact, the tricks have been specifically selected with that point in mind. However, the more you practice the string tricks, the easier you can make them look and the more deceptive they will therefore be, making them ideal for the beginner.

The Fingers and the Loop

You Gotta Have a Gimmick
a 24-inch piece of string or rope

How the Trick Appears:
The magician places a long loop of string over an audience member's forefinger. The magician places his finger upon that of the audience member's finger and twists the string.

When the magician suddenly draws away, the string comes free of both fingers! It seems impossible that the string could be released from the loop around the audience member's finger.

The Secret:

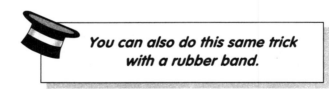

1. Loop the string over the audience member's forefinger (see Figure 1).

2. With your left hand, hold the string taut, while the right forefinger lifts up the left end of the string and passes it over the right (see Figure 2).

3. Twist the right hand so that the thumb may be inserted between the crossing and the audience member's finger (see Figure 3).

4. Turn the right hand again, keeping the thumb in position, and place the right forefinger upon the audience member's finger (see Figure 4).

5. Keep the fingers touching. When you slide the thumb free, the loop can be drawn away by your other hand (see Figure 5).

You can also do this same trick with a rubber band.

134

FIG. 1

FIG. 2

FIG.3

FIG.4

FIG. 5

The Fingers and the Loop

On and Off

You Gotta Have a Gimmick
a 36-inch loop of string

How the Trick Appears:

The magician lays a length of string on the table so that it forms a double loop, or a figure eight. He then places his finger in one of the loops and pulls both ends of the cord. His finger is caught in the loop.

When he lets a few audience members try this, their fingers are always caught as well. This, of course, is quite natural as the finger is pressed against the table, it must be caught when the ends of the string are finally pulled.

The magician then forms the loop again, but this time, the string does not catch his finger when it is pulled away!

The Secret:

1. Lay the string exactly as shown in Figure A.

2. If a finger is placed in either loop, as indicated by the asterisks, it will be caught when the ends of the string are pulled as in Figure B.

3. When the string is laid as shown in Figure C, the finger my be placed in either loop shown by the asterisks. This time, when the ends are pulled, the string will come clear of the finger.

4. An ordinary observer will notice no difference between A and C.

136

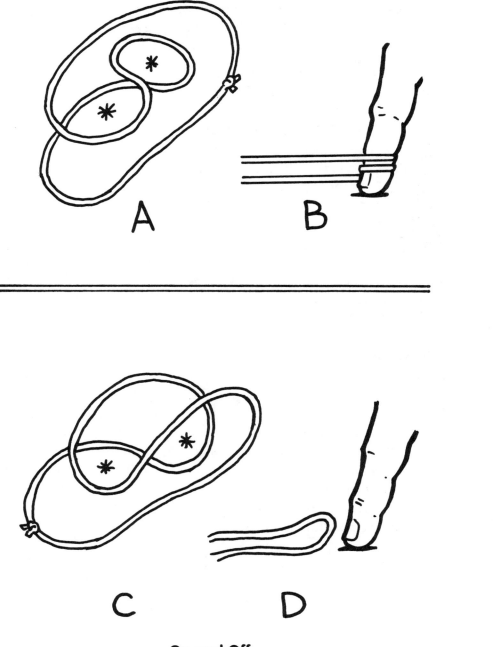

A

B

C

D

On and Off

Knots That Are Not

You Gotta Have a Gimmick
a 36-inch piece of rope or string

How the Trick Appears:
The magician takes a piece of string and ties it in three knots, one at a time. When the magician then pulls the ends of the string or rope, the knots draw together and then come apart so that not a knot remains!

The Secret:

1. The first step is to tie a single knot as shown in Figure 1. Note that end A will come closest to you—in front of the knot.

2. Next, tie a second knot, forming loops X and Y. Again, be sure that the right-hand end (A) comes to the front as illustrated in Figure 2. This is done by carefully following the explanatory illustrations. The result will be the ordinary square knot shown in Figure 2.

3. The trick lies in the third knot. Push end A through X from the front, again bringing it around to the front, then pushing it through Y. This is clearly shown in Figure 3.

4. When you pull both ends, the knots will disappear.

FIG. 1.

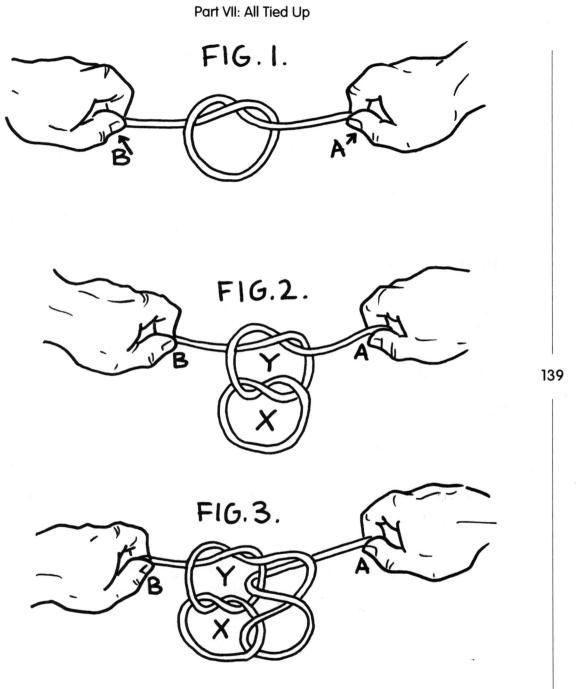

FIG. 2.

FIG. 3.

Knots That Are Not

The Pencil and Loop Trick

You Gotta Have a Gimmick

a pencil with a small hole drilled 3/4 of an inch from the top,
and a loop of string that is approximately 1/3 of the length of
the pencil once it has been threaded through the hole and tied.

How the Trick Appears:

The magician has a pencil with a loop of string through a hole drilled in one end. The loop is much shorter than the pencil (see Figure A). The magician approaches an audience member and loops the pencil on the person's buttonhole (see Figure B). This seems like an impossibility as no one can remove the pencil without cutting the string.

The Secret:

140

1. If the loop is pushed through the buttonhole at the beginning, the pencil cannot be slipped through the loop. This is where everyone fails in this trick.

2. Figure C shows the only method. You must spread the loop over the buttonhole and the cloth first, and then push the pencil through as in Figure D. To remove the pencil, the operation is reversed.

Many magicians used this as a give-away item, with their name and number imprinted on the pencil. The magician would place the pencil in the audience member's buttonhole and would tell him that he would incur 13 years of bad luck if the pencil was broken or if the string was cut.

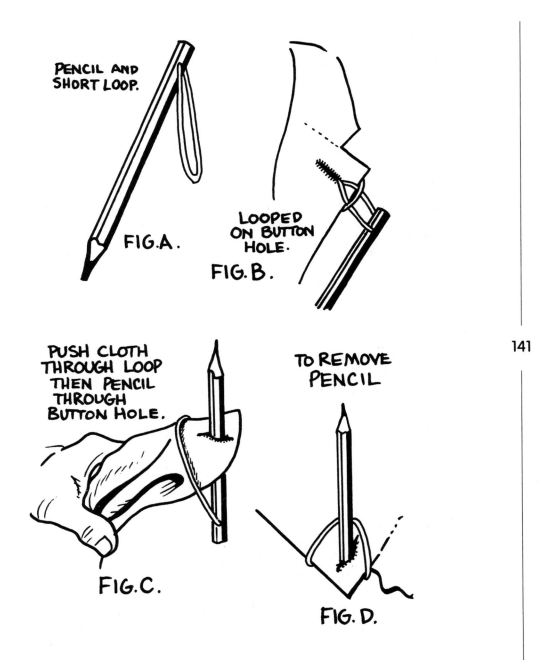

PENCIL AND SHORT LOOP.

FIG. A.

LOOPED ON BUTTON HOLE.

FIG. B.

PUSH CLOTH THROUGH LOOP THEN PENCIL THROUGH BUTTON HOLE.

FIG. C.

TO REMOVE PENCIL

FIG. D.

The Pencil and Loop Trick

141

Tying the Thumbs

You Gotta Have a Gimmick
a strong piece of string or rope

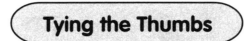

How the Trick Appears:

The magician's thumbs are tied together with a piece of string. The string is pulled very tightly and there seems to be no chance for the magician to pull his thumbs apart.

Φ The magician slides his coat over his hands and removes it, yet his thumbs are still tied together! He turns his back for a moment, and when he shows his hands, they are locked through the arm of a chair, but the thumbs are still tied, and the string has been cut.

The Secret:

142

1. First, hold the string under your thumbs as shown in Figure 1.

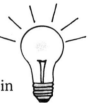

2. Fold your hands so that the audience sees your fingers as in Figure 2.

3. In folding your hands, keep one finger inside the second finger of your right hand, and with it press down the center of the cord as in Figure 3.

4. The absence of one finger from your folded hands will never be detected by the keenest observer. The thumbs hide the finger from above, and they may be tightly tied, as illustrated in Figure 4.

5. It is an easy matter for you to get your thumbs apart by slipping your finger through the loop. This allows plenty of slack for the thumbs, and one of them may be released. When the thumb is placed in the loop, the finger goes in, and draws down, making the slack disappear.

ONE

TWO

THREE

FOUR

Tying the Thumbs

Part VIII

Presenting Knots
Knot Tricks With Added Effects

Though the added effects in this chapter are simple to perform, they are somewhat different from ordinary knot tricks, and have therefore been grouped in a category of their own. These tricks require some emphasis on presentation, as some are performed "under cover" or require special appliances. Reserve them for the right audience or suitable occasions when they will be most effective.

Three Amazing Knots

You Gotta Have a Gimmick
a six-foot piece of rope

How the Trick Appears:
The magician holds a six-foot length of rope between his hands, casually coils it, and gives it a hard fling, retaining one end as he does so. Instantly, three knots appear at intervals along the rope!

The Secret:

1. These "Spirit Knots," as they are sometimes called, are secretly formed by first laying the left end of the rope across the open left hand, which should be palm up.

2. Next, bring the right hand palm up beneath the rope, grip the rope loosely and turn the right hand toward the left, so that the right turns knuckles down (Figure 1).

3. This automatically forms an underhand loop, which the right hand hangs over the extended left fingers (Figure 2).

4. Move the right hand along the rope to the right and repeat the maneuver with the second loop. Now go farther to the right and form a third loop the same way.

5. All this is done openly and aboveboard. Now comes the simple but unnoticed move that produces the climax. As your right hand places the final loop, you dip the right thumb and forefinger through all three loops and grip the left end of the rope (Figure 3).

6. Bring the end back through the loops, draw it clear, and give the rope a fling with the right hand, retaining the end that you have gripped. (Figure 4). That action will form the knots along the rope. Don't be stingy with the loops; make them ample and the trick is sure.

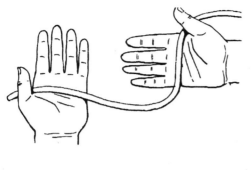

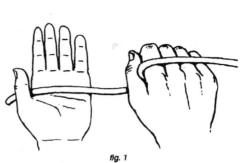

fig. 1

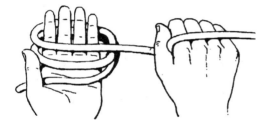

fig. 2

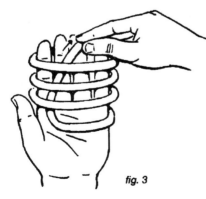

fig. 3

fig. 4

Three Amazing Knots

Houdini's Knot Mystery

You Gotta Have a Gimmick
a 30-foot piece of rope

How the Trick Appears:

The magician shows the audience a rope measuring 30 feet or more, and then says he is going to have the "spirits" tie knots in it. To prove that some such force is necessary, he ties one end of the rope around one person's waist, and the other end around another person's waist. The main portion of the rope remains coiled on the floor between the two audience members (Figure 1).

Because the two ends are tied around the waists of two different people, the magician tells the audience that only "spirits" could perform such a trick. And, because spirits only work in the dark, the lights are turned off.

The magician then tells the two volunteers to move to opposite corners of the room so the "spirits" will have space to operate in. When the magician calls for the lights, the rope is stretched taut between the two audience members, with knots at regular intervals.

The Secret:

1. This is a large-scale version of the *Three Amazing Knots* trick. When coiling the rope on the floor, use underhand loops as described in the *Three Amazing Knots*. In this case, however, the loops must be very large—three feet across or more.

2. Once the lights are out, pick up all the loops together and drop them over the head and shoulders of the audience member on the left (Figure 2). By then sending that person to the far corner of the room, the rope will be drawn out automatically and the knots will appear (Figure 3).

3. Make sure you choose the proper audience member to be the person on the left. Either choose a friend who will work with you or someone who will blame the "spirits" for the knots.

148

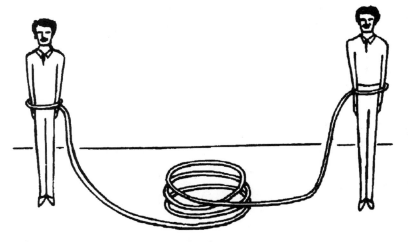

fig. 1

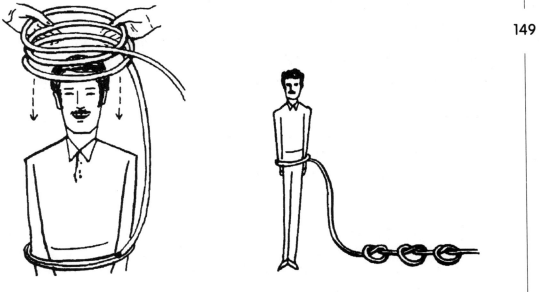

fig. 2

fig. 3

Houdini's Knot Mystery

Knot-Dissolving Tube

You Gotta Have a Gimmick
a toilet paper tube and a piece of string

How the Trick Appears:

This fantastic tube dissolves the knots inserted into it! To prove the tube's special properties, the magician takes a light rope and ties a simple overhand knot around the outside of the tube so that the left end (A) is the upper end, and the right end (B) is the lower end (Figure 1).

The magician brings the right strand of the rope a few inches downward, holding it against the tube with the left thumb while he carries the right end of the rope clear around the tube with the right hand. He then ties another knot, just like the first, using end "B" in the process.

The magician then brings the right end downward again and holds the rope with his left thumb, while the right hand carries its end (B) around the tube and ties a third knot. This is near the lower end of the tube and the rope end (B) now dangles free (Figure 2).

The magician now takes the upper end of the rope (A) and drops it down through the tube (as indicated by the arrow in Figure 2). When it comes out of the bottom, he gives it to an audience member to hold.

Next, he draws all the knots upward in a bunch and as they come off the top, he pushes them down the tube, stating that the dissolving process is ready to begin. He promptly takes the free end of the rope (B) and gives it to another audience member to hold.

Obviously, the knots are safe and sound within the tube, but when the two volunteers pull on the ends of the rope, the magician shows the knots are gone. He does this by moving the tube back and forth.

150

The Secret:

1. This trick works if you follow the instructions to the letter. You actually untie the knots when you drop the upper end down through the tube, but you have to stuff the knots in with it to complete the job.

2. This can be done with string as well as rope, and any cardboard tube will do. Just make sure the cord is long enough, and the more mysterious or pseudo-scientific talk you add, the more impressive it will be.

151

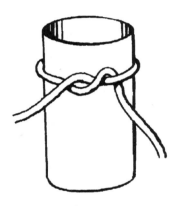

fig. 1

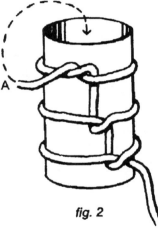

fig. 2

fig. 3

Knot-Dissolving Tube

Rings and Loops

You Gotta Have a Gimmick

three-foot piece of rope (string won't work) and two different rings (for the purpose of explaining this trick, we have opted to use a black and white ring)

How the Trick Appears:

The magician threads the black ring on the rope, which is tied with a hard, firm knot, so as to form a loop some three or four inches in diameter, from which the black ring dangles. The white ring is then slid over one end of the cord, which is tied to form an upper loop of about the same size (Figure 1).

Three or four more knots are added at the top to make it more secure. Two audience members hold the extended ends of the cord and a large handkerchief is thrown over the hanging loops and rings (Figure 2).

The magician then announces that he will make the rings change places despite the solid knot that intervenes. He shows the positions of the rings, covers them again and works beneath the cloth for a few moments. When the handkerchief is removed, the rings have indeed changed places! To everyone's amazement, the white ring is now on the lower loop and the black ring is on the upper loop, with the knot in between them still intact. In fact, the knots have to be untied to remove the rings from the cord.

The Secret:

1. Despite its seemingly impossibility, the trick is very simple. Underneath the cloth you grasp the loops on each side of the center knot and push them towards each other.

2. Thanks to the stiff rope, the knots loosens and you can run the upper ring along the rope and through the knot, down to the lower loop (as shown by the arrows in Figure 3).

152

3. Reverse the process with the other ring, bringing it up through the loosened knot to the upper loop.

4. Pull the knot again so it will be tight and no one will know how you worked the trick. With a little practice this can all be done quite rapidly.

fig. 2

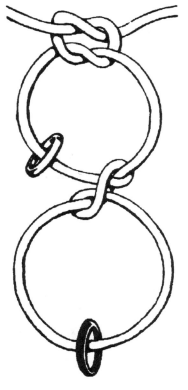

fig. 1

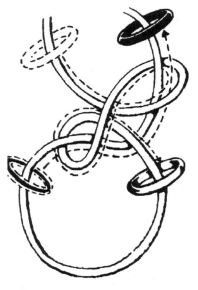

fig. 3

Rings and Loops

String and Scissors

Two hundred years ago, the chevalier Pinetti astounded Paris by escaping from a doubled chain looped through metal rings which were attached to his feet, and locked to a post.

You Gotta Have a Gimmick
string and scissors

How the Trick Appears:
Figure 1 shows the chains before the escape. Figure 2 explains how the escape was accomplished.

The Secret:
1. Figure 3 demonstrates the principle behind the escape with a looped string and a pair of scissors: draw the loop through one handle and then the other, and then spread the loop over the points of the scissors.

154

fig. 1

fig. 2

fig. 3

String and Scissors

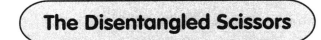

The Disentangled Scissors

You Gotta Have a Gimmick
a three foot piece of rope and a large pair of scissors

More than 50 years later, a writer named Cramer supplied a more detailed version of the "String and Scissors" trick, called "The Disentangled Scissors" in his book, *The Secret Out*. People have been doing the trick ever since.

How the Trick Appears:
This is an old, but classic trick. A piece of rope is fastened to the scissors as shown, and both ends of the rope are held by the hand or tied firmly to a post or other immovable object (Figure 1).

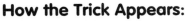

The Secret:
 1. To remove the scissors from the rope, take the loop end of the string and pass it through the upper handle as shown by the dotted line.

155

2. Let the loop be carried still further towards the lower handle, until it is passed completely around the scissors (Figure 2). You can then remove them, as the rope will slip easily through the handles.

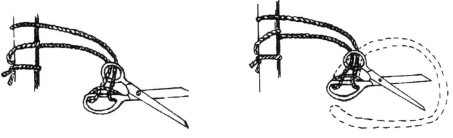

fig. 1

fig. 2

The Disentangled Scissors

Ropes through Coat

You Gotta Have a Gimmick

*two six-foot or longer pieces of rope and
a few inches of white cotton thread*

How the Trick Appears:

The magician holds the two long ropes side by side and pushes the ends through one sleeve of a coat and out the other (Figure 1). He then gives one end of each rope to two audience members (Figure 2). When the ropes are pulled, the jacket falls to the ground (Figure 3).

The Secret:

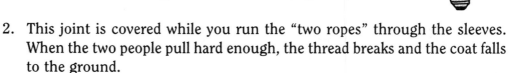

156

1. The secret is that the two ropes originally shown are not single ropes. They are each doubled in the center, and their centers are bound together with thread (Figure 4).

2. This joint is covered while you run the "two ropes" through the sleeves. When the two people pull hard enough, the thread breaks and the coat falls to the ground.

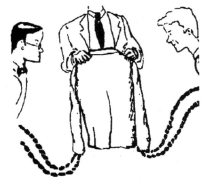

fig. 1

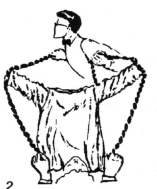

fig. 2

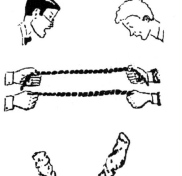

fig. 3

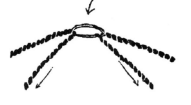

fig. 4

Ropes through Coat

Ring on a Rope

You Gotta Have a Gimmick
three- to four-foot piece of rope and any large ring

How the Trick Appears:
The magician gives someone a large flexible ring then allows his wrists to be loosely tied with a rope between them. He then takes the ring and turns his back for a few moments. When he turns around the ring is now on the rope (Figures 1-3).

The Secret:
1. To accomplish this, work the ring under one wrist loop, over the hand and onto the rope (Figure 4).

158

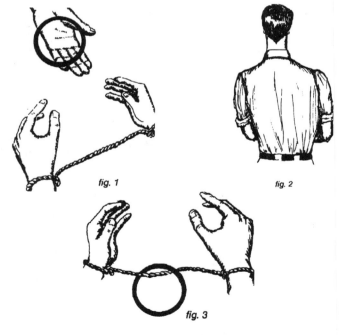

fig. 1

fig. 2

fig. 3

fig. 4

Ring on a Rope

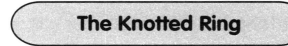

The Knotted Ring

You Gotta Have a Gimmick
a three-foot rope and a large ring

How the Trick Appears:
A ring is tied to the center of the rope. When the two ends are pulled, it surprisingly drops off.

The Secret:
1. Run the rope through the ring from left to right (Figure 1).

2. Tie a loose overhand knot above (Figure 2) and bring the right end below the ring as indicated by the arrow (Figure 2).

3. Carry the end under the rope, bring it up and push it down through the original loop as shown by the arrow (Figure 3). Pull the ends of the rope in opposite directions. The ring will drop from the rope as the knot dissolves.

159

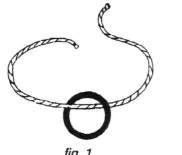

fig. 1

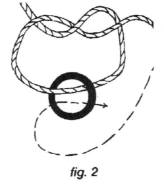

fig. 2

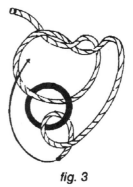
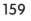

fig. 3

The Knotted Ring

Double Cut and Restored Rope

You Gotta Have a Gimmick
a four-foot piece of rope and a pair of scissors

How the Trick Appears:
In this simple trick, the magician cuts a rope into three pieces and then knots them together. After a few magic passes, the knots are gone and the sectioned rope is restored in full.

The Secret:
1. Actually, you don't cut the rope into three lengths at all. You begin by showing a single rope, then double it into two bights up and down (Figure 1), so that you can tie the bights in the manner of a Catshank (Figure 2).

160

2. Draw out the loops to equal lengths so that only an inch or less of the rope projects from each end. State that you have divided the rope into three sections—which you have—and that you will now cut the sections apart. For the purpose of appearance, you pretend to do just that.

3. Instead of cutting the bights, use a pair of scissors to cut the standing part of each rope, just below the knot (Figure 2). That is, you really cut off the rope ends and the knots with them, but the knots naturally stay in place.

4. You now take the rope by its new "ends." The two knots, spaced equally along the rope, give the false impression that the rope has been cut into three pieces.

5. To "restore" the rope, take one end in your the left hand. With your right hand, slowly coil the rope around the left, drawing the right hand down the rope as you do so. As you come to the knots, carry them along with the right hand, which takes them off the end.

6. You must now dispose of the telltale knots. The simplest way is to reach for the scissors that you used to cut the rope. Retrieve them from the table with the right hand, leaving the knots in their place. Wave the scissors, saying that they cut the rope and will now magically restore it. Lay the scissors aside, take the ends of the rope and stretch it straight, showing it is "restored."

While ordinary clothes lines will work for most tricks, many magic shops sell a cotton rope that is easy to cut and works well for all rope tricks.

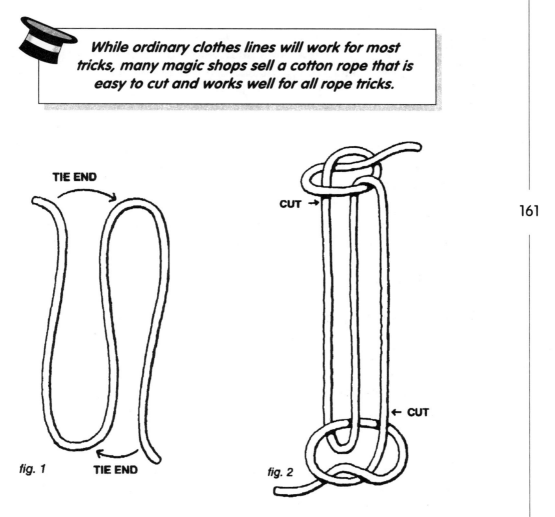

fig. 1 TIE END fig. 2

Double Cut and Restored Rope

161

Comedy "Cut-Rope" Climax

You Gotta Have a Gimmick
a 36-inch piece of rope and three "extra" knots

How the Trick Appears:

Disposal of the cut-off knots is the only problem with the "Double Cut" rope trick. It's not much of a problem if you have some article lying on the table to hide them in, such as a handkerchief that can later be pocketed with the knots. However, there is a simple solution to the problem, that is to let the knots dispose of themselves as part of a comedy climax.

The Secret:

1. In this case, you don't bother to coil the rope around your left hand. You give the ends to an audience member and tell him or her to hold the rope taut. Then you turn to another person and ask, "Are you sure those are knots?" When he or she answers "yes," you announce, "All right, I'll restore the rope by magic and since we don't need the knots, you can have them."

2. With that, you pluck the knots from the rope and hand them out while you take the rope and show it intact. Oddly enough, this bold handling of the knots makes the trick even more puzzling to some people.

Comedy "Cut-Rope" Climax

162

Part IX

Keep an Open Mind
M e n t a l M y s t e r i e s

It's mind over matter in this section! What really matters are the clever mental mysteries that will have your friends thinking you really can read their minds. These mental mysteries have become so popular in recent years that many people who witness them cannot believe that they are trickery and attribute them to extrasensory perception (ESP). This makes it all the better for the beginner since no one is looking for deception. Inject a few of these "brain busters" into your program and you will have people talking about them, not only to other people, but to themselves!

The Chosen Name

You Gotta Have a Gimmick
a sheet of paper and a pen

How the Trick Appears:
The magician gives an audience member a piece of paper that he has folded into nine sections. He tells the person to write a desired name in the center, then to write a name in each of the other portions. The magician then asks the person to tear

the paper along the folds, so as to form nine separate slips that are then dropped into a hat. The audience will agree that the magician only has a one in nine chance of discovering the slip that bears the desired name. When the magician then reaches into the hat and pulls out the correct slip, everyone is surprised.

The Secret:

1. The secret to this trick will surprise you with its simplicity! Your original sheet of paper has smooth cut edges. When the sheet is torn along the folds, the result is rough edges. The only slip that will have all four edges rough will be the center slip bearing the desired name.

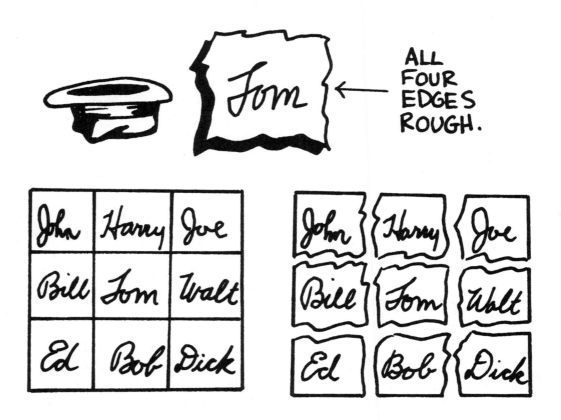

The Chosen Name

Amazing Figures

You Gotta Have a Gimmick
pen and paper

How the Trick Appears:

The magician takes a piece of paper and writes down the number 142857. He asks an audience member to name a number between one and eight. Suppose the number seven is given. The person who called out the number is told to multiply the large number by seven. The result is 999,999. The slate is turned over and that number is found on the other side.

The Secret:

1. For whatever reason, many people will call out seven when given the choice of choosing a number between one and eight. Therefore, the number 999,999 will be accurate.

2. However, for those who do not choose seven, the multiplication is still done and you can point out that the figures have not changed.

3. For instance, the number 142857, when multiplied by three, becomes 428571. In this case, you should cross out each figure, proving that the same ones are still there, and then call for the multiplication of another number between one and eight. This will work every time with the numbers two, three, four, five and six. When seven is called, the trick is brought to its conclusion.

4. You should stand away and call out the figures of the total, without even knowing the number used to multiply. Simply start with the lowest figure, saying: "One, two, four, five, seven, eight." If the person says, "wrong," then you will know that seven was the number he chose to multiply by. All you need to do in this case is quickly reply, "I am naming the figures you multiplied. Turn the piece of paper over and you will find your answer."

BACK OF SLATE

Amazing Figures

Always Nine

You Gotta Have a Gimmick
pen and paper

How the Trick Appears:
The magician asks an audience member to write a number consisting of three different figures. He then tells the person to reverse the number and subtract the smaller from the larger number. Before the audience member has a chance to finish, the magician predicts that the middle digit is nine.

The Secret:
1. You will be right because the middle digit will always be nine no matter what numbers are used!

167

$$
\begin{array}{r} 583 \\ -385 \\ \hline 198 \end{array}
\qquad
\begin{array}{r} 421 \\ -124 \\ \hline 297 \end{array}
\qquad
\begin{array}{r} 615 \\ -516 \\ \hline 099 \end{array}
\qquad \mathbf{'9'}
$$

Always Nine

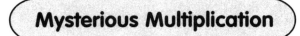

Mysterious Multiplication

You Gotta Have a Gimmick

pen and paper

How the Trick Appears:

The magician instructs an audience member to write down the number 12345679. He asks the person to name his favorite number. Suppose the person says five. The magician tells the person to multiply the number he wrote down by five. To his surprise, the answer is a row of fives—his favorite number!

The Secret:

1. This works because 45 is 5 times 9. If the number one is his favorite number, he should be told to multiply it by nine. If he says 2, have him multiply it by 18; for 3, multiply by 27; for 4, multiply by 36, for 5, multiply by 45; for 6 multiply by 54; for 7, multiply by 63; for 8, multiply by 72; for 9, multiply by 81. Note that the trick will not work if the number eight is used.

Mysterious Multiplication

Tell the Time

You Gotta Have a Gimmick
a watch and a trained assistant

How the Trick Appears:
A watch is set to any time, as long as the minute hand points to one large number and the hour hand to another. Then, the watch is laid face down on the table. This is done while the magician is absent. Entering the room, he places his fingers on the back of the watch and after a short meditation names the numbers to which each hand points.

The Secret:
1. The key to pulling this trick off is having a well-trained assistant. The watch itself is used as the tip-off. Your assistant takes it upon himself to lay the watch on the table, which only the two of you know has been divided into 12 imaginary squares. Your assistant lays the watch in the proper square to designate the number to which the small hand points.

2. The key to figuring out the number the large hand is pointed at is the position in which the watch is set. Assuming the outer end of the table signifies twelve o'clock on the dial, the assistant turns the watch so that its stem points to the number indicated by the large hand.

> *Using a wristwatch instead of a pocket watch is easy. Fold the wristwatch in half so that there is only a watch band at one end of the watch. Then use the stem of the watch as described.*

SMALL HAND LARGE HAND

Tell the Time

The Watch that Stops Itself

You Gotta Have a Gimmick
a watch and magnet

How the Trick Appears:
When the magician lays the watch on the table, it stops ticking. Everyone could hear it ticking until it was laid there!

The Secret:
1. Any watch may be used (preferably a cheap one).

2. Under the tablecloth there is a hidden magnet. As soon as you put the watch upon it, it will stop.

Never do this trick with an expensive watch as placing it on the magnet may prevent it from keeping accurate time in the future.

171

The Book Mystery

You Gotta Have a Gimmick
two small identical books

How the Trick Appears:
The magician states that he has a wonderful sense of perception. Showing the book, he hands it to an audience member and tells him to name a number between 1 and 150. He then requests a number between 1 and 100 from a second person. Suppose that the numbers 94 and 27 are the numbers given.

The magician tells the first audience member to turn to page 94 and to count down to the 27th word. The magician steps outside the room while this is being done. When he returns to the room he announces the correct word.

The Secret:

1. The key to this trick is simple; you need two identical books. A small book, such as a pocket dictionary, is best.

2. When you step outside the room, you will take the duplicate book out of your pocket and note the word that has been chosen.

3. When you return to the room, you will surprise the audience by producing the correct word.

The Color Test

You Gotta Have a Gimmick

four different colored skeins of yarn

How the Trick Appears:

The magician turns his back and an audience member drops one skein into the magician's hand. Still holding his hands behind his back, the magician faces the audience for a few moments. He then turns his back again so that everyone can see the yarn in his hand. The magician then accurately names the color.

The Secret:

1. When you first face the audience, break off a bit of yarn from the skein you are holding behind your back.

2. When you turn away again, bring the hand with the torn off bit of yarn to your forehead, pretending you are thinking. This will enable you to see the color of the bit of yarn.

Four different crayons can be used instead of the yarn. Write on or scrape a bit of the crayon on your fingernail. When you hold your hand up to your head you will see the color.

1. RED
2. BLUE
3. BLACK
4. WHITE

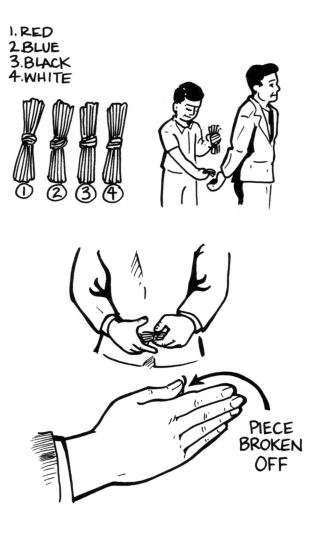

PIECE
BROKEN
OFF

The Color Test

Which Pencil?

You Gotta Have a Gimmick

four different colored pencils, cold cream (or a bit of Blue Tac) and a trained assistant

How the Trick Appears:

Several pencils are borrowed from audience members. As the magician turns his back and puts on a blindfold, the pencils are placed in a hat. One is removed and passed from person to person to "create a magnetic force" and then dropped back in the hat. The magician picks out each pencil and holds it to his forehead. He repeats this until he announces he has the pencil that was selected.

The Secret:

1. You must have an assistant to do this trick. On one finger, your assistant has a small dab of cold cream or Blue Tac. He should be the last person to hold the pencil. Just before he places it in the hat, he puts either the dab of cold cream or Blue Tac on the pencil.

2. When you hold the pencil to your forehead, slide your hand from the center to the ends. The moment your fingers touch the cold cream or Blue Tac, you will recognize it and announce that you have the chosen pencil.

3. Draw the pencil through your hands as you return it and the presence of the cold cream will never be known.

When using an assistant, practice the trick with him until you are sure he knows exactly what to do.

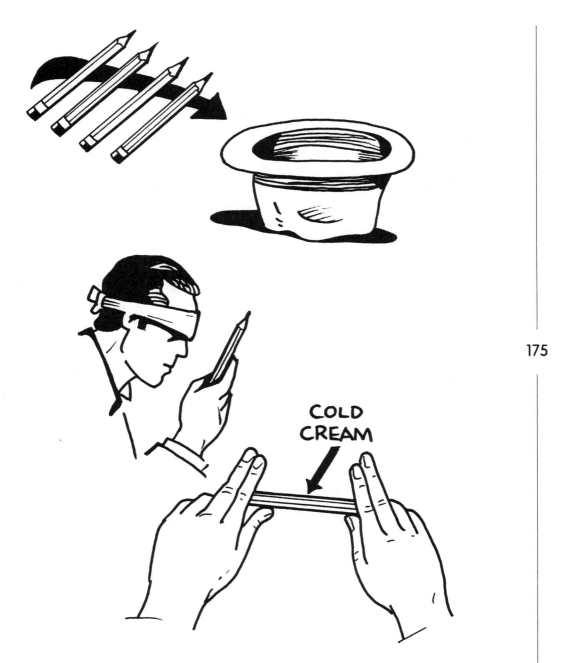

COLD CREAM

Which Pencil?

Mental Card Detection

You Gotta Have a Gimmick
a deck of cards and a trained assistant

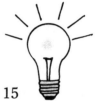

How the Trick Appears:
While the magician is absent, a card it selected from a deck, and the deck is then shuffled and laid on the table. Upon his return, the magician picks up the deck, runs through it and finds the selected card.

The Secret:
1. You must have an assistant for this trick. He, as well as the others, knows the selected card.

2. Before the trick, you and the assistant divide the table into 15 imaginary squares (see diagram).

3. After the card has been chosen, the assistant will lay the deck of cards on the proper "square" to show the value of the selected card.

4. In order for you to know the suit, the assistant lays the deck of cards in a certain position: vertically for Diamonds, diagonally to the right for Hearts, diagonally to the left for Clubs, and horizontally for Spades.

5. You should always look through the deck to find the chosen card. This will divert suspicion from the real method and allow the trick to be repeated.

176

ACE	2	3	4	5
6	7	8	9	10
NO CARD	JACK	QUEEN	KING	JOKER

Mental Card Detection

Think of a Number

You Gotta Have a Gimmick

five circles filled with "magic numbers" and a pencil

How the Trick Appears:

The magician invites an audience member to concentrate upon a number no greater than 30. When he has chosen the number, the magician gives him a pencil and shows him the chart of numbers illustrated here for you.

 The magician tells the person to tap each group that contains his number with the pencil. Immediately after he has done so, the magician writes down the number the person is thinking of.

The Secret:

1. This is a very reliable method of discovering the number a person is thinking of. All you need to do is note the central number of each group that he touches with the pencil. When you add these central numbers, your total will be the number he has in mind.

2. Suppose the audience member is thinking of the number 25. He taps the group in the center, the group at the lower left, and the group at the upper left. The central numbers are 16, 1 and 8, respectively. The total is 25.

3. Be sure that the person studies each group carefully to make sure that his number is there. Let him wait, if he wishes, until he has studied all the groups before he begins to tap.

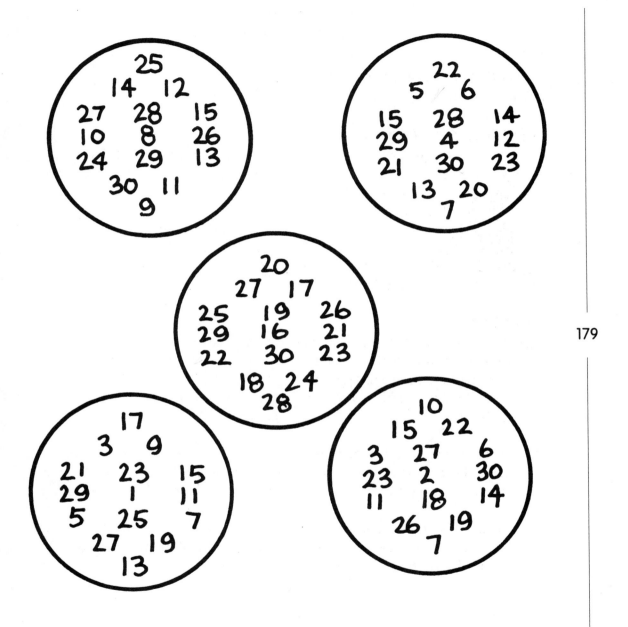

Think of a Number

Part X

A Bag of Tricks
by Mike Shelley

I've Got Your Number

You Gotta Have a Gimmick
pencil, paper, and a calculator

How the Trick Appears:
Have everyone in your audience think of a number. You will have them add, multiply, subtract and divide and when they are all done you will tell them the total they are thinking of.

The Secret:
1. This is a self working mathematical trick. Just follow the steps that follow and you will be doing this impressive effect: Have everyone think of a number. Tell them they can use pencil and paper or even a calculator if they wish, but to choose a number that they can work with. We will use 12.

Steps	**Example**
Multiply their number by 2	12 x 2 =24
Add 2 to their total	24+2 = 26
Divide their total by 2	26 ÷ 2 = 13
Subtract the original number	13 - 12 = 1

Their answer is 1.

The answer will be one regardless of how large or small the original number is.

Red, White & Blue

182

You Gotta Have a Gimmick
a well trained assistant and a group of people

How the Trick Appears:

Here's a real easy trick that everyone can do. Tell everyone that you are going to leave the room and that they are to pick any thing in the room. When you come back you are going to identify that object.

Prior to performing the trick, you meet secretly with your assistant. You explain to him that you will leave the room and everyone will agree on an object. When you return to the room he is to point to various objects in the room. He will point to random objects, but right before the first object he will point to something red. (He can not point to anything red prior to this.) The next object he points to will be the chosen object, which you will be able to identify.

To be more effective the first time you do the trick, your assistant will point to an item and ask you each time "Is this it...?" The second time you do

it your assistant says "Is it...?" (and names the object pointed to). The third time your assistant just points to the objects.

The next time you leave the room he will do the same thing, but this time the color will change to white. The third time you repeat the trick your new color will be blue.

It's All Done with Mirrors

You Gotta Have a Gimmick
a red marker, a black marker, a mirror, a sheet of paper

How the Trick Appears:
Pull out two markers: one red and the other black. Tell your friend that one of them is really a magic marker. Whichever one your friend picks will become the magic marker. We will pretend that he chooses red. Tell him that you are go-

183

ing to write two words, one with the black marker and the other with the red one. Then write the following using the red for the word "tomato."

<table>
<tr><td>T</td><td>C</td></tr>
<tr><td>O</td><td>E</td></tr>
<tr><td>M</td><td>L</td></tr>
<tr><td>A</td><td>E</td></tr>
<tr><td>T</td><td>R</td></tr>
<tr><td>O</td><td>Y</td></tr>
</table>

Now, hold both words in front of a mirror. The word "TOMATO" will be unchanged, but the word "CELERY" will be reversed. You can also proceed to write "HOT" and "COLD" in the same way.

The Secret:
1. The mirror does all the work. The letters in the word "TOMATO" are the same in the mirror as when you are looking directly at them.

On the other hand, all the letters used in the word "CELERY" will become reversed. Can you think of any other words that will work?

When you are first doing this trick you might want to use the same color over and over. As you feel more confident you can add the additional colors.

The Chosen Word

You Gotta Have a Gimmick

a telephone, a friend, a duplicate copy of a phone book he has, a pencil and paper

How the Trick Appears:

You call your friend and tell him to get his local phone book. This person can open to any page he wants. He is asked to do some multiplying and addition to the page number. When he finishes, out of the thousands of possibilities, you give him the name and phone number he is looking at.

The Secret:

1. You have a copy of the same phone book that the person is using. By using the secret mathematical formula that follows, it leads you to the exact name and number he is thinking about.

2. Have your friend open to any page he wants and have him multiply the page number by 10. Have him select any of the first 9 names in any column on that page, then have him add the number of the line to his total. Have him then add 25 to that total and multiply this sum by 10. Add the number of the column to the total.

3. Now ask him to tell you his total and secretly subtract 250 from it. The last digit indicates the column, the number to the left indicates the line, and the remaining numbers indicate the page.

Example:

If the person used page 234, the 4th name in the 2nd column you would have him do the following steps:

page number 234 times 10	**=**	**2340**
line number 4		**+ 4**
		2344
add 25		**+ 25**
		2369
multiply by 10		**x 10**
		23690
add column		**+ 2**
total person gives		**23692**
you secretly subtract 250		**- 250**
		23442

the last digit tells the column	**2**
the number to the left tells the line	**4**
the remaining number(s) tell the page	**234**

Just look up page 234, line 4, column 2 and tell him what name he picked. Your friend will be amazed.

This will work with any book or magazine as long as you have a duplicate copy. Instead of using a column number, have him tell you how many words over his word is from the left margin.

APPENDIX

Magic Shops

Abbot's Magic Company
124 St. Joseph Street
Colon, MI 49040
616-432-3235

All Decked Out
4700 N. 31 Court
Hollywood, FL 33021
954-987-1039

Al's Magic Shop
1012 Vermont Avenue NW
Washington D.C. 20005
202-789-2800

Balloon Box
2416 Ravendale Court
Kissimmee, FL 34758
407-933-8888

Brad Burt's Magic Shop
4204 Convoy St Suite 109
San Diego, CA 92111
619-571-4749

Chaspro Family Fun Shop & Magic Co.
603 East 13th Avenue
Eugene, OR 97401
503-345-0032

Davenport's Magic
7 Charing Cross Underground
Shopping Arcade
London, England WC2 4HZ

Daytona Magic Shop
136 South Beach St
Daytona Beach, FL 32114
904-252-6767

Denny & Lee Magic Studio
325 S. Marlyn Avenue
Baltimore,MD 21221
410-686-3914

Diamond Magic
515 Lowell Street
Peabody, MA 01960
800-330-2713

Eddie's Novelty & Trick Shop
262 Rio Circle
Decatur, GA 30030

Elmwood Magic & Novelty
507 Elmwood Avenue
Buffalo, NY 14222
716-886-5653

Empire Magic
99 Stratford Lane
Rochester, NY 14612
716-227-9760

Flosso Hormann Magic Co.
45 West 34 Street #608
New York, NY 10001
(212) 279-6079

Hank Lee's Magic Factory
127 South Stree
Boston, MA 02111
781-395-2034

Haines House of Cards
2514 Leslie Avenue
Norwood, OH 45212
513-531-6548

Hollywood Magic Inc.
6614 Hollywood Blvd.
Hollywood, CA 90028
323-464-5610

La Rock's Magic
3847 Rosehaven Drive
Charlotte, NC 28205

L&L Publishing
P.O. Box 100
Tahoma, Ca 96142
800-626-6572

Magic, Inc.
5082 North Lincoln Ave.
Chicago, IL 60625
773-334-2855

Magicland
603 Park Forest Center
Dallas, TX 75234
972-241-9898

Magical Mysteries
4700 N. 31 Ct.
Hollywood, FL 33021
954-987-1039

Meir Yedid
P.O. Box 2566
Fair Lawn, NJ 07410
201-703-1171

Steven's Magic Emporium
2520 East Douglas
Wichita, KS 67214
316-683-9582

Twin Cities Magic & Costume Co.
241 West 7th Street
Saint Paul, MN 55102
612-227-7888

Wizard Craft
P.O. Box 1557
Pleasant Valley, NY 12569
914-635-9379

Publications

GENII
The International Conjuror's Magazine
4200 Wisconsin Avenue, NW
Suite 106-384
Washington , D.C. 20016

MAGIC
The Independent Magazine
for Magicians
7380 S. Eastern Avenue
Suite 124-129
Las Vegas, NV 89123
702-798-4893

Summer Camps

West Coast Wizards Camp
PO Box 1360
Claremont, CA 91711
909-625-6194

Tannen's Magic Camp
24 West 25th Street
Second Floor
New York, NY 10010
800-72-MAGIC

Good Places to Visit

There are numerous places where you can find additional information about magicians, magic tricks, and the history of magic. The following are really good places to start:

Library: Your local library may have many books on magic. Look in 793.8 for books on magic, but also look at 793.2 for parties and party games, and 793.87 for juggling.

Book Stores: Usually will offer many titles in their games or hobby sections.

The Internet: There are now hundreds of sites for magicians, magic tricks, and magic shops. A good starting place is http://allmagic.com.

High Schools and Colleges: Many places of learning offer after school or evening courses in magic.

TV Specials: David Copperfield, Lance Burton, and other famous magicians have periodic magic specials on TV.

Science Museums: In certain large cities many of the science museums will teach or have a local magician come to perform.

Travel: Many of the major hotels in Las Vegas have magicians performing in their shows. Some Magician's have their own shows, such as Lance Burton at the Monte Carlo, Sigfried & Roy at the Mirage, and Spellbound, an all magic review at Harrah's. The Boardwalk Holiday Inn features Dixie Dooley's show and a magic museum. Ceasars Palace is where David Copperfied performs when he is in town.

Branson, MO and Atlantic City also offer a wide range of magicians at the various clubs and casinos.

Museums

The Houdini Museum
1433 N. Main
Scranton, PA 18508
570-342-5555

The Houdini Historical Center in the Outagamie Museum
330 East College Avenue
Appleton, WI 54911
920-733-8445

189

NOTES

NOTES

NOTES

NOTES

NOTES

NOTES

NOTES

NOTES

Fell's

Official Know-It-All Guide™

Check out these exciting titles in our Know-It-All™ series, available at your favorite bookstore:

- ❏ Fell's Official Know-It-All™ Guide: Advanced Hypnotism
- ❏ Fell's Official Know-It-All™ Guide: Advanced Magic
- ❏ Fell's Official Know-It-All™ Guide: The Art of Traveling Extravagantly & Nearly Free
- ❏ Fell's Official Know-It-All™ Guide: Budget Weddings
- ❏ Fell's Official Know-It-All™ Guide: Career Planning
- ❏ Fell's Official Know-It-All™ Guide: Contract Bridge
- ❏ Fell's Official Know-It-All™ Guide: Coins 2003
- ❏ Fell's Official Know-It-All™ Guide: Cruises
- ❏ Fell's Official Know-It-All™ Guide: Defensive Divorce
- ❏ Fell's Official Know-It-All™ Guide: Dreams
- ❏ Fell's Official Know-It-All™ Guide: Easy Entertaining
- ❏ Fell's Official Know-It-All™ Guide: ESP Power
- ❏ Fell's Official Know-It-All™ Guide: Getting Rich & Staying Rich
- ❏ Fell's Official Know-It-All™ Guide: Health & Wellness
- ❏ Fell's Official Know-It-All™ Guide: Hypnotism
- ❏ Fell's Official Know-It-All™ Guide: Knots
- ❏ Fell's Official Know-It-All™ Guide: Let's Get Results, Not Excuses
- ❏ Fell's Official Know-It-All™ Guide: Money Management for College Students
- ❏ Fell's Official Know-It-All™ Guide: Mortgage Maze
- ❏ Fell's Official Know-It-All™ Guide: No Bull Selling
- ❏ Fell's Official Know-It-All™ Guide: Nutrition For a New America
- ❏ Fell's Official Know-It-All™ Guide: Online Investing
- ❏ Fell's Official Know-It-All™ Guide: Palm Reading
- ❏ Fell's Official Know-It-All™ Guide: Relationship Selling
- ❏ Fell's Official Know-It-All™ Guide: Secrets of Mind Power
- ❏ Fell's Official Know-It-All™ Guide: So, You Want to be a Teacher
- ❏ Fell's Official Know-It-All™ Guide: Super Power Memory
- ❏ Fell's Official Know-It-All™ Guide: Ultimate Beauty Recipes
- ❏ Fell's Official Know-It-All™ Guide: Wedding Planner
- ❏ Fell's Official Know-It-All™ Guide: Wisdom in the Office